logolounge

2,000 International Identities by Leading Designers

CRAVEN COLLEGE

Bill Gardner and Cathy Fishel

ROCKPORT PUBLISHERS

ROCKPORT

First published in the United States of America by

Rockport Publishers, Inc.
33 Commercial Street
Gloucester, Massachusetts 01930-5089

Telephone: (978) 282-9590
Fax: (978) 283-2742
www.rockpub.com

ISBN 1-56496-909-6

10 9 8 7 6 5

Design: Gardner Design
Layout & Producton: *tabula rasa* graphic design
Cover Image: Gardner Design
Project Manager/Copy Editor: Nancy Elgin
Proofreader: Stacey Follin

Printed in China

Dedicated to my four families:

First, my wife, Andrea, and my favorite daughter, Molly.

Second, my fellow workers, Elisabeth, and Susan especially.

Third, to my treasured confidants and partners in *LogoLounge*, Cathy, Troy, Brian, Pam, and Lisa.

Fourth, to all the great designers who "got" the idea and lit the fire that's become www.LogoLounge.com.

—*Bill Gardner*

To Bill for believing in someone he had never even met face-to-face, and to the guys of Boy Scout Troop 178 of Morton, Illinois, from your assistant Scoutmaster. You make my life a joy.

—*Cathy Fishel*

contents

introduction

When LogoLounge.com first went online in late 2001, we had no idea how enthusiastic a response we would receive from some of the design industry's most talented and prolific designers. A who's who of designers from six continents began uploading thousands of logos to the Web site, and they continue to do so today. Lesser-known but still exciting individuals and firms have also come on board, adding even more depth and breadth to the collection.

As this enormous resource began to gel, the logical next step seemed to be an annual—a printed companion—that would assemble the best and most exciting work from the site each year. But rather than just produce a one-dimensional collection without context, we decided to create a book with (a) substantial editorial content, and (b) an Internet site that will allow you to search the book's contents easily and quickly. Simply log onto http://www.logolounge.com/book1, and you will be able to swiftly navigate through the more than two thousand logos in this book by searching by designer, client, industry, type of logo, or keywords.

A panel of nine renowned identity designers from around the globe selected this collection. Their choices form an inspirational resource and reference tool through which you can explore the trends and influences driving international branding today. In the book and on the companion Internet site, the logos have been arranged categorically to allow for fast access and to show off the dramatic diversity of styles used to depict similar subject matter.

You will also have the opportunity to investigate the thinking premier design firms use as they tackle the identity process for clients as diverse as Madonna and the city of Hong Kong. Peer into the project files behind the naming and design of the implike TiVo logo. Follow airline British Midland's graceful transformation into the stylish bmi. Learn how designers help brand-new firms get off to a healthy start, as well as how they revitalize long-standing organizations such as a hundred-plus-year-old dairy and a centuries-old museum.

Our goal is to inspire and educate you without exhausting you (or your supply of sticky notes) in the process. LogoLounge.com and this new book are truly hybrids of print and Web: You may read at your leisure, or do a quick, intuitive search. Our sincere hope is that *LogoLounge* will open up more time for you to do what you like best: design.

—Bill Gardner and Cathy Fishel

jurors

Sean Adams
AdamsMorioka, Inc., Los Angeles, CA

Mexican Doorbell logo, by Art Chantry
"How can you resist a logo with a dead dog? I loved this because it was unexpected, smart, and perfectly executed. The hand-drawn quality gave it a vitality and immediacy that a hard-line, smooth mark would have missed."

Noreen Morioka
AdamsMorioka, Los Angeles

Dracula logo, by Chase Design Group
"I'm always a sucker for logos that evoke an emotional response in a concise and poignant way. I tend to like the humorous more than the serious, but this logo is one that provokes an immediate response and narrative. I wish that more entertainment work could be as wonderfully refined and memorable."

In 1993, Sean Adams and Noreen Morioka founded AdamsMorioka with the idea of applying clarity, purity, and resonance to content, form, and business. The duo has been named to the ID40 list, *I.D. Magazine*'s annual list of the forty most influential international designers. Both have lectured around the world, been nominated for the National Design Award, and are Fellows of the International Design Competition at Aspen. They also frequently serve as jurors for leading competitions.

Adams is past president of the Los Angeles chapter of the American Institute of Graphic Arts (AIGA-LA) and has served on AIGA's National Board. He teaches design theory and typography at the California Institute of the Arts.

Morioka is the current president of AIGA-LA.

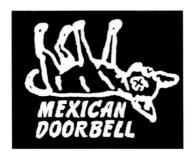

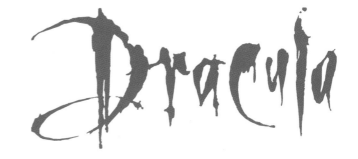

Mary Lewis
Lewis Moberly, London, England

National Association for Child Development and Education logo, by Pat Taylor Inc.
"I chose the symbol for the association because it said a great deal in a very edited way. Two heads linked by an arm, or two eyes and a smile, is an intriguing image that creates a powerful, emotive communication."

Mary Lewis, creative director of Lewis Moberly, has won numerous design awards, including the industry's highly prestigious British Design and Art Direction Award for Outstanding Design and the Design Business Association International Design Effectiveness Awards Grand Prix. She has chaired the BBC Graphic Design Awards, is a past president of British Design and Art Direction, and is a member of the Royal Mail Stamps Advisory Committee. In 2001, Lewis received the British Design and Art Direction President's Award for Outstanding Achievement.

She speaks to groups around the world and has participated in such prestigious gatherings as Leaders in Design, a series of creative workshops initiated by Prime Minister Tony Blair. Lewis also coauthored the book *Understanding Brands.*

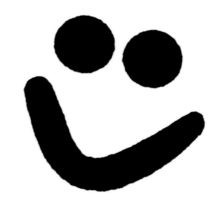

Rex Peteet
Sibley Peteet Design, Dallas, TX

Elisabeth Andersen logo, by Jon Flaming Design

"The mark has an unstudied spontaneity about it. It is very gestural, so it doesn't stand still—ideal for women's fashion. I am uncertain of the inspiration, but it reminds me of the famous photograph of Marilyn Monroe standing on the subway grate, dress billowing. All of the information you need is there with a few very ingenious shapes. The attitude and arms are implied with negative space and body gesture. So, with no unnecessary elements, the designer captures the free-spirited loveliness and elegance of this woman and leaves just enough to the viewer's own imagination."

After studying design at the University of North Texas, Rex Peteet worked with several prestigious firms, including The Richards Group and Pirtle Design. Twenty years ago, he and partner Don Sibley founded their own company, Sibley/Peteet Design, in Dallas. In 1994, Peteet founded the firm's second office in Austin, where he now lives and works.

He has won numerous regional and national design awards, and his work is frequently published in international design periodicals and annuals; it is also represented in the permanent collection of the Library of Congress. Peteet serves on the advisory boards of AIGA-Austin and the Creative Circus Design School in Atlanta. He also judges, lectures, and teaches seminars for universities and design organizations across the country.

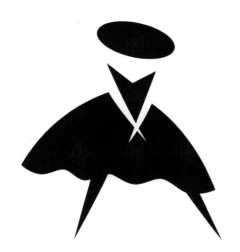

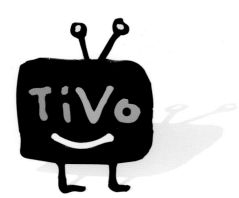

Woody Pirtle
New York, NY

TiVo logo, by the Cronan Group

"I love the honesty and approachability of the TiVo logo. In an arena of planets, globes, rings, shooting stars, swooshes, and every other cosmic gewgaw being used to identify some gadget or service in our new digital world, TiVo is a breath of fresh air."

After running his own successful design practice in Dallas for ten years, Woody Pirtle joined Pentagram in New York in 1988. He is well known for his economical logotypes and witty posters, and his identity and publication design work perennially put him at the top of lists of awards and most-wanted speakers. His work is exhibited worldwide and is in the permanent collections of many museums, including the Museum of Modern Art, the Cooper-Hewitt Museum, and the Zurich Poster Museum.

Marcel Robbers
Braue; Branding and Corporate Design,
Bremerhaven, Germany

New England Patriots logo, by Evenson Design Group
"Simplicity, use of color, strength, a clear message,
dynamism, and longevity are the key elements of the
logo in my point of view. The simplicity in the different
elements works together perfectly with the colors, and
thus creates the logo's overall bold appearance. It has
the strength and ability to convey a clear message even
when the text isn't added."

Marcel Robbers is art director of Braue, a company
specializing in branding and corporate design that was
founded by his boyhood friend, Kai Braue. His unique
solutions have helped his many international clients
build and strengthen their brands. Robbers's work in
logos and corporate identity has been published in
many graphic design magazines and books in Germany and abroad, and he has received numerous
awards. In his spare time, Robbers is the renowned
singer for his heavy metal band, 2nd Heat.

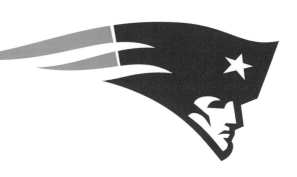

Felix Sockwell
Felixsockwell.com, New York, NY

National Museum of Australia logo, by SPATCHURST
"It's great to be smart, to nail a logo into its name or
function. But over the years, I've learned it's better to
be brave—to craft something from the heart. God
walked into the room when this one was handed out.
It could be for anything, but somehow only feels right
in Australia."

Felix Sockwell is a Texas native. He cut his teeth
designing logos for friends after work. Barbecue
sauces, restaurants, bars, five hair salons—everyone
lined up for his famous free logos. It got so bad, he
says, that coworkers nicknamed him "FREElix" and
threw change into his office. Eventually, however,
awards and attention arrived, and he moved from
Dallas to San Francisco and then to New York, where
he founded what is now the Brand Integration Group

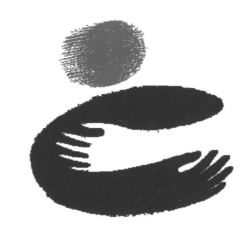

at Ogilvy & Mather. He left the agency after creating
a number of large identity programs and became an
illustrator in the summer of 1999. Since then, he has
built a strong reputation in the field of identity design.

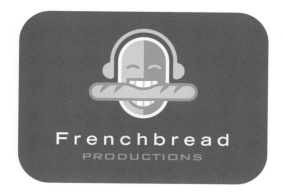

Peter Watts
Watts Design, Melbourne, Australia

Frenchbread Productions logo, by Dotzero Design
"Simplicity, nice colors, and a campaignable idea all combine for a memorable and emotive logo."

Graphic design has been a lifelong passion for Peter Watts, founder of Watts Design. He has embraced an extensive range of design disciplines, including packaging, annual reports, corporate communication, environmental design, and corporate identity. His strong commitment to quality and innovation consistently puts his communication solutions at the forefront of trends, where they win awards and publication in annuals around the world.

Ann Willoughby
Willoughby Design Group, Kansas City, MO

Richmond Raceway logo, by Gardner Design
"I always appreciate simple solutions that work on many levels. The racetrack and the double Rs make for a playful visual palindrome. Great color, too."

Ann Willoughby is the founding partner and creative director of Willoughby Design, formed in 1978. Willoughby provides strategic oversight for Fortune 500 companies as well as brand start-ups. She and her seventeen associates specialize in retail brand identity and brand communications, and Willoughby also frequently lectures to design, education, and business groups. She has served on the advisory board of the Kansas City AIGA and is currently on the steering committee of the national AIGA Brand Design group. Teaching is one of her passions, and she works with students and children whenever possible. She and her firm have won a number of industry awards and had their work published in many leading design publications.

portraits

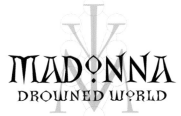

Design Firm	Chase Design Group
Client	Madonna
Project	Drowned World Tour

In the regular dog-eat-dog corporate world, an identity is crafted so that it is evergreen. It should last for the lifetime of the company, with only minor tweaking required now and then to update it. But in the entertainment world, although identity is just as important, it is an ephemeral thing, so it has to make a significant impact because it's there only for the briefest moment. Chase Design Group's 2001 assignment to create the identity and collateral materials for Madonna's Drowned World Tour was a case in point, and it presented significant additional challenges as well.

"A tour is a product, like Disneyland or any other experience," says principal Margo Chase. "You are branding an experience. The brand has to have all of the same things any logo must have to work on TV, in newspapers, on T-shirts. It's not very different from a corporate logo when you get into applications. But entertainment clients want something trendy, not permanent."

> "They look at our portfolio and see Madonna and think we don't know how to do corporate. That is an issue for us."

Chase has worked with Madonna and her management company before on major projects such as the artist's *Like a Prayer* album and Girlie Show tour. But this project proved to be a particular challenge: The logo had to be completed in two weeks and had to include cultural references to everything from the Wild West to Eastern religion.

"The show was kind of an Asian-Cuban-Latino-disco-cowgirl thing. From a design standpoint, we were all wondering how we could get all of this to go together," the designer recalls.

Round one of the logo design was a whirlwind. Chase was leaving for a week's vacation in Paris when she got the original call. She wanted to turn it down, but eventually she agreed to take

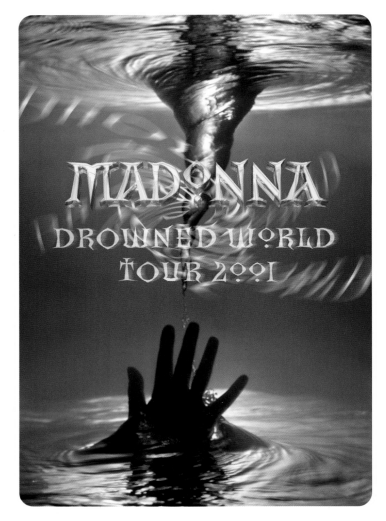

The finished tour poster with the new logo in place.

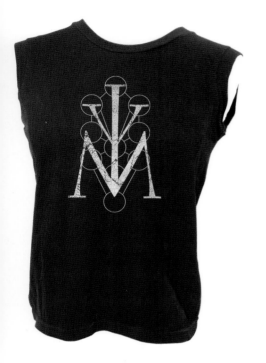

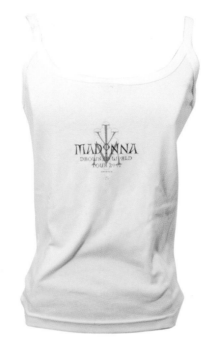

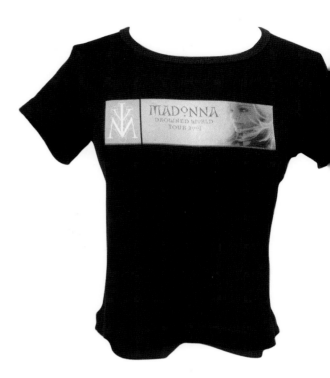

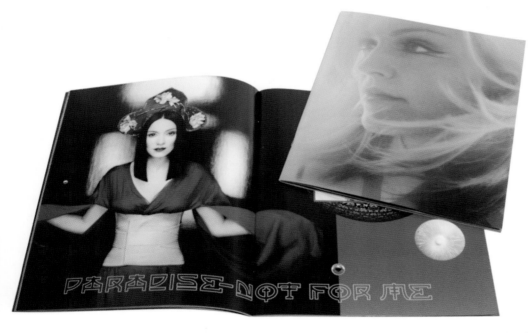

Promotional T-shirts use the logo in different ways.

The final tour book and an example of type that the Chase Design Group created for song titles.

In the entertainment world, identity is important, but it is a more ephemeral thing. It's there for only the briefest moment.

These logos were part of what the Chase Design Group proposed to Madonna and her managers in the first round of logo development. The designers had been given a "global techno" direction, as well as sketches of the proposed stage design and Madonna's song list for the tour. Here, they explored types with Asian and Middle-Eastern influences as well as techno styles.

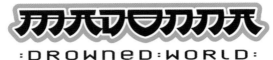

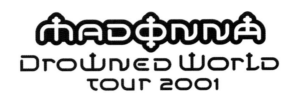

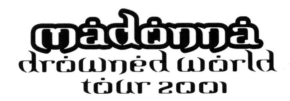

her computer with her. For a solid day, she sat in her Parisian hotel room and generated page after page of logos.

Chase said her trials were based on the "global techno" direction provided by Madonna's staff, the artist's very diverse song list, and sketches from the set designer that were more like science fiction than anything else.

Although her work was well received, Chase discovered upon returning to her Los Angeles studio that the concept for the tour had been redirected: It would explore the Kabbalah as a life influence instead. Madonna is an avid student of the ancient Judaic philosophical system.

With research, Chase was able to reference many Kabbalistic symbols in the second round of designs, including the Ten Sfirot, a diagram of circles representing the ten realms of the upper worlds that are reached through prayer, spiritual transformation, and meditation.

The title of the tour, Drowned World, is another reference to the Kabbalah. It says that the harder you struggle for material things, the faster you will sink, as opposed to reaching the higher realms by being spiritual and relaxed.

"Madonna is a Kabbalah scholar, but I am a scholar of iconography. I knew right away what she wanted, how to show the religion's meaning through symbolism," says Chase. In the final designs, for instance, out

of the M in Madonna emerged the Tree of Life, another powerful symbol connoting the three levels of the cosmos—the Underworld, the Earth, and the Heavens. Crosses, orbs, and fountains also found their way into the second set of trials.

Chase continued to push the global-techno angle through the line styles and letterforms she created, but in the end, a historically inspired, Gothic design was selected. This disappointed the designer for two reasons: First, she felt that other designs she had presented were more appropriate for the tour, and second, she works hard to avoid being known as "that Gothic designer," and many of the rejected logos were more of a stylistic stretch for her.

In addition to the rushed schedules and temporal nature of entertainment identities, Chase notes that this type of work presents other challenges.

"It's not difficult for [my studio] to switch tracks from entertainment to corporate work, but it is difficult to explain that to other clients. They look at our portfolio and see Madonna and think we don't know how to do corporate. That is an issue for us," Chase says. "Sometimes we leave our entertainment work out of the portfolio when we are presenting to corporate clients."

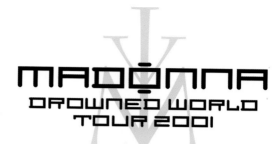

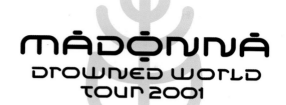

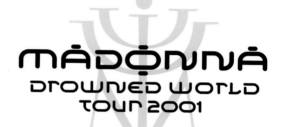

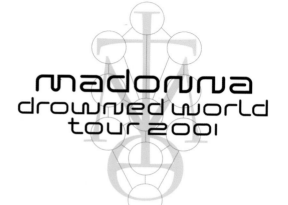

After the first round of logos was presented, the Chase designers were asked to redirect the concept to the Kabbalah, which Madonna has studied. The diagram of circles behind many of these logos represents the ten realms known as the Ten Sfirot—the Upper Worlds that can be reached through prayer, spiritual transformation, and meditation. The icons are based on the Tree of Life, another powerful Kabbalistic symbol.

The two logos below were selected to go to color, and after the color round, the one on the right was selected. "I was disappointed because I preferred the other one," Margo Chase says. "I think that it was more interesting and it was certainly more of a stretch for me stylistically."

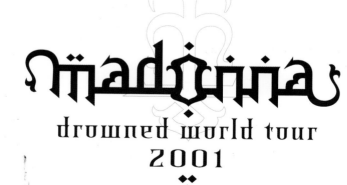

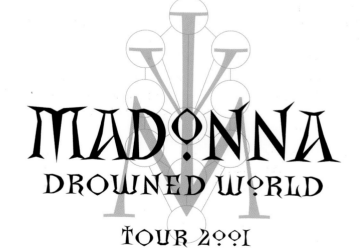

Little Buddha
Identity Design

Chase Design Group, Los Angeles, CA

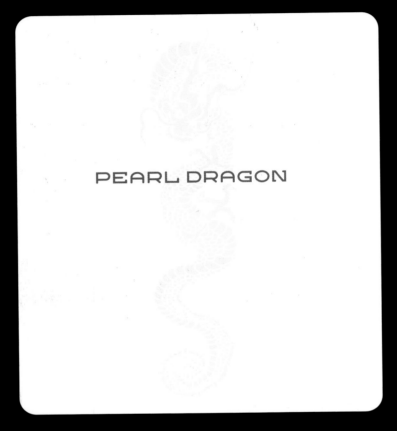

PEARL DRAGON

Next, Chase created more graphic, simplified versions of the little Buddhas, keeping the mood lighthearted to avoid causing any religious offense. But even though she and the client were very pleased with the results, these designs never saw the light of day because a lawsuit was threatened by the owner of another restaurant with a similar name.

That's when Little Buddha unexpectedly became Pearl Dragon, an upscale, conservative, dine-in establishment. The new name was like a cliché come to life, says Chase. "There are only 19 million Chinese restaurants around with 'dragon' in their names," she notes.

Nevertheless, she committed herself to finding the most elegant dragon image available and took great care in redrawing and modernizing it. She also designed a squared-off, but more modern typeface for the restaurant's name. Its vertical orientation mimics the restaurant's marquee outside, also designed by Chase's group.

Chase admits that she still prefers the original Little Buddha identity. But, she adds, having to come up with two completely different personalities for the same client was certainly a good exercise in stretching creatively.

This is the story of a restaurant with a split identity. When Chase Design Group began working with a pair of nightclub owners to develop an identity for a new eatery, its designers were thinking young, trendy, and casual. When the designers finished the job, however, they were told that everything—including the name of the establishment—had changed.

At the start, Little Buddha was to be a bar/restaurant that would offer casual dining, drinks, and carryout. The owners wanted to attract a young crowd interested in seeing and being seen by others in a club atmosphere.

As her client described the proposed business, Margo Chase had visions of a kitschy, round-cheeked Japanese cartoon character often seen on Asian calendars and greeting cards. "These are very Hallmark-like drawings of Japanese children wearing little costumes," the designer says. "I showed the client the kind of drawings I was talking about, and I think they kind of got it."

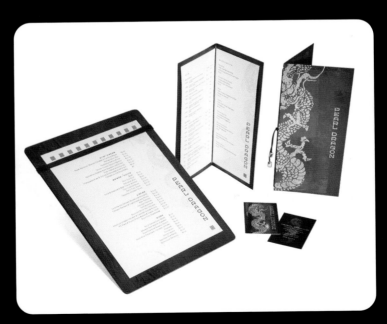

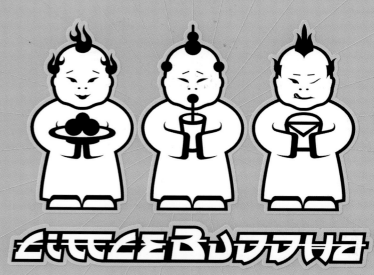

eat drink takeout

PEARL DRAGON

ASIAN KITCHEN 15229 SUNSET BLVD PACIFIC PALISADES CA 90272 PH: (310) 459-9790 FX: (310) 459-9560

PEARL DRAGON

ASIAN KITCHEN

TOMMY STOILKOVICH

HEAD DRAGON SLAYER

15229 SUNSET BLVD
PACIFIC PALISADES
CA 90272
PH: (310) 459-9790
FX: (310) 459-9560

PEARL DRAGON

ASIAN KITCHEN 15229 SUNSET BLVD PACIFIC PALISADES CA 90272

Design Firm	Simon & Goetz Design
Client	Rotwild
Project	Corporate Identity

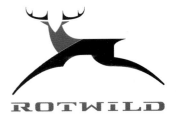

ROTWILD

What's missing from many corporate identity projects, says Rüdiger Goetz, principal with Matthias Simon of Simon & Goetz (Frankfurt, Germany), is the truest benefit to the client's brand—that is, business success. Many designs produced today are visually exciting and some even win industry awards, he acknowledges, but what is the actual worth of those designs? Do they really help the client for whom they were designed?

Simon & Goetz's identity design for Rotwild, a brand new company making ultra-premium mountain bikes is a good example of how an effective brand image is created from the ground up, and how that identity is crucial for corporate efficiency.

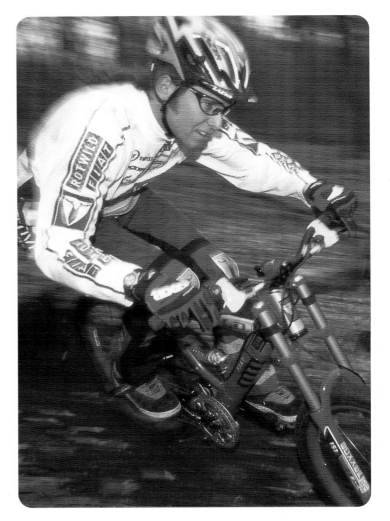

> Rotwild's founders chose to pursue a "preference strategy" versus a "mass strategy."

Normally, Simon & Goetz works with relatively large corporations, but the Rotwild project was different. Three engineering students, almost done with their university studies, saw that there was room in the mountain bike market for a new niche: a high-cost, high-tech bike with the cachet of German engineering. They turned to the design firm for help. Simon & Goetz jumped at the opportunity to create everything for the fledgling company, from Rotwild's name and logo to its bike and accessory designs.

"We put a strong focus on the actual product design—its graphic language or style," explains Goetz. His firm was an ideal choice for a start-up client with little budget for market research: Simon & Goetz already had experience in branding for the bicycle market from having worked with a much larger client. Much of the design firm's work was based on previous studies, in addition to information the new client had gathered and a detailed national and international competitor comparison study.

"They could see the hype in the mountain bike market that was mainly coming from the U.S., where the sport was rooted," adds Goetz. "Bikes became a fashion statement and very contemporary.

Rotwild has a strong, masculine, aggressive brand identity, which was created by Simon & Goetz Design of Frankfurt, Germany, to appeal to the person who wants much more than just a biking experience.

"We put a strong focus on the actual product design—its graphic language or style."

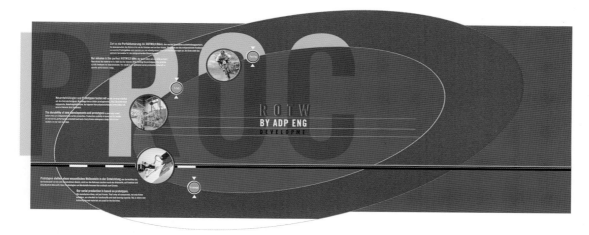

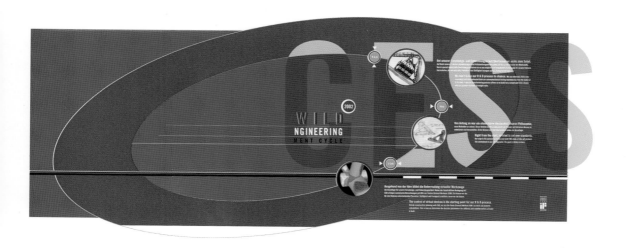

Aluminum silver, red, and black have become the Rotwild brand's signature colors. In fact, the color scheme and its consistent use over the years have become synonymous with what the company prefers to call a "cycling experience," not a mere bike ride. These pages from the company's catalog illustrate what the brand is all about: Both the identity and the bikes have an almost military look.

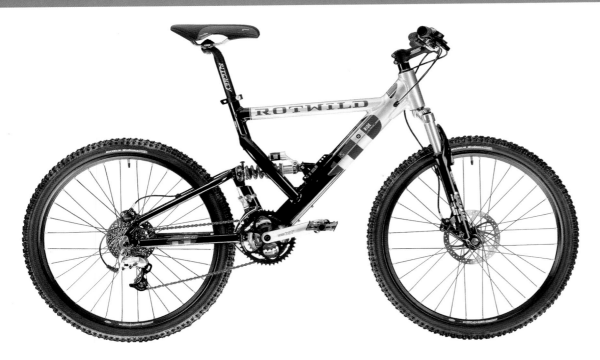

"Technology is a strong discriminating factor with German engineering. This brand had to be attractive, outstanding in its physical shape, unique in its features, and memorable," says Rüdiger Goetz. "With a high price, it had to have a high appearance."

But the market had too many competitors at the low end, and [these entrepreneurs] knew they couldn't compete in a mass market where low price is always the main factor. At the same time, the few really premium brands available at the time were American."

Their success would come from stressing the technological superiority of the then-unnamed Rotwild brand. "Technology is a strong discriminating factor with German engineering, considering our cars, machinery, and so on. This new German brand also had to be attractive, outstanding in its physical shape, unique in its features, and memorable. With a high price, it had to have a high appearance," he says. Rotwild's founders chose to pursue a "preference strategy" versus a "mass strategy" in their branding.

"Bikes became a fashion statement and very contemporary."

The first thing Simon & Goetz did was to create a brand model and describe it in the same way a person might be. "It is simple and helps the agency and the client see the brand. A fully integrated brand [can only] happen if all of the individuals involved have a similar level of understanding and valuation for the brand," Goetz says.

For the new bike company, the designers devised this simple, descriptive sentence for the brand's personality: "[The company] offers the most competitive technology in mountain biking by German engineering." They also developed a set of three core values: German technology and engineering, competition competence, and masculinity.

The statement and value together create a certain image and, ideally, a positive prejudice about this personality. This prejudice must be

successful because it is the basis for every potential social and emotional contact the brand will make. In the end, the brand image of Rotwild was boiled down to "the most technical mountain bike" or "the only German hard-core mountain bike."

Now the firm could work on the brand's name. Each of the three concepts that were considered was presented to the client with a corresponding visual concept. The first was based on the entrepreneurs' original idea of selling kits with which buyers could build their own bikes. Playing off the English word *kits* brought to mind the German *kitz,* which means "small deer," and the speed and habitat of a deer seemed appropriate for a fast mountain bike. But the name lacked masculinity—99 percent of Rotwild buyers are highly educated males between the ages of 30 and 45 years—and strength.

"It was a good first step for our exploration, but it was not a preferred direction. In addition, the inventors gave up the kit idea early on," Goetz recalls.

The second viable concept was related to mountain biking the north wall of the Swiss mountain called Eiger. Although it isn't the highest peak in the Bernese Alps, the mountain is famous for being an exceptionally difficult and dangerous climb. To the designers, then, using the word *nordwand* as a concept representing extreme challenge and pairing it with the Capricorn goat symbol felt appropriate.

But then a third concept, actually a hybrid of its predecessors, emerged, says Goetz. "*Rotwild* is the name of a common type of deer [in Germany], and as a German, when I hear this name, I visualize a very conservative

Rotwild's Web site also relies on red, black, and silver. Action is key to the brand: The person shopping on this site is definitely a thrill seeker, so the experience here must also be intense.

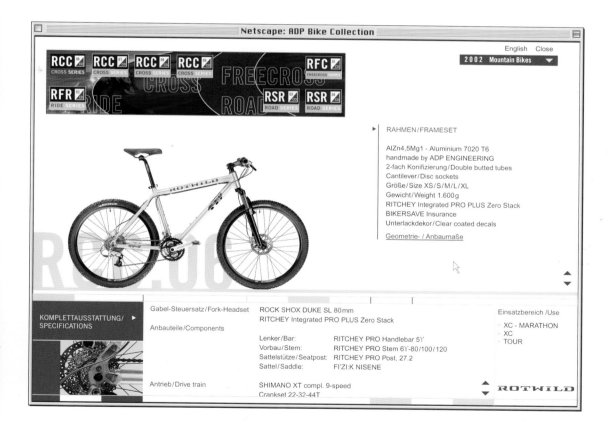

and old-fashioned hunting scene. It's very German. It's short and remarkable." Goetz notes that the name also implies speed and wildness, as well as aggressiveness, even to the customer who doesn't speak German.

The name also is highly memorable because it applies an old-fashioned sensibility to a contemporary, technology-heavy brand. "The strange combination of conservatism and an ultramodern appearance also give the brand acceptance in a very hip and young market segment without relying on formal trend-oriented elements like color or graphics," the designer adds.

Simon & Goetz also took the stance that the product was a "German cycling device." That unemotionally split the brand away from being a mere bicycle: Instead, it's a total technology experience having a much higher perceived value than a "bike" does. This enabled Rotwild to become the antithesis of the traditional mountain-biker lifestyle, where colors and trends are the main discriminating factors that pit brands against each other.

The next step was to develop a logo. The designers wanted the new identity to behave in a way that no brand in the market had previously. The new line would bring "mobility to nature," explains Goetz, with the benefit of high-tech German engineering. So any visual symbol would have to embody the nature of the sport, a deer, and a sense of technology.

Simon & Goetz's designers developed a very masculine, hard-edged image of a deer. The logo looks modern, but it also hints—with stylized antlers and body shape—of classic German hunting scenes. The head of the deer is used alone in some applications in a manner similar to the way a trophy head is exhibited on the wall of an old hunting lodge.

"There was nothing like it on the market," recalls Goetz. "This was an old-fashioned name with a very technical brand experience."

The typography the designers developed matches the brand's values: For text other than the wordmark, they selected Trade Gothic, which Goetz describes as "an American version of Futura. It served the need of good readability on the product and for copy," he notes.

It also contrasts well with the hand-drawn logotype, which was constructed from extended letterforms that illustrate the speed aspect of the brand. In addition, its crispness communicates the product's high value and plays with the ambiguous idea of military technology in its high-tech, stenciled style.

The design of the bike itself followed suit. The bike had to look technical, competitive, and masculine. "It needed to look very hard and aggressive, almost weaponlike," the designer says. The product's design is ruled by a simple brand characteristic: the use of unique, constant, and noticeable materials and color. "We developed a graphic style that is almost reminiscent of the graphical surface of sophisticated military and defense technology," Goetz adds. "Or imagine the elements you see on the wing of an airplane."

Since its first line of bikes was released six years ago, Rotwild has only used polished aluminum and red, gray, and white application colors. To differentiate between various price points, applications, and technologies, the color code is varied slightly. This creates very high brand recognition—a simple approach but one that no other brand was employing at the time.

It was very important that the design language was first developed with the focus on the actual bike design and its graphics, says Goetz. In the second step, the brand identity is applied to media like print or the Web. Establishing a visual bond between the product and all media vehicles continues to be the design team's goal.

"This is definitely a well-known and respected bike in the German market. Only two thousand bikes are sold each year, given its price, but it was chosen by a leading biking magazine as the most desirable mountain bike on the market," Goetz says. "The client also continues to win awards for design, typography, and product design, but their success as a business is the most important thing."

It's a total technology experience having a much higher perceived value than a "bike" does.

Emagic
Identity Design

Simon & Goetz Design, Frankfurt, Germany

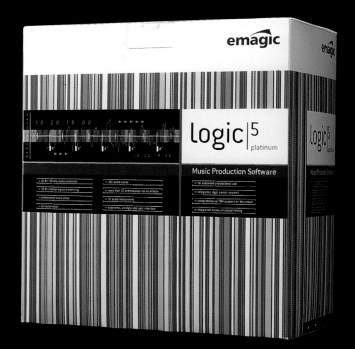

Not every identity design project is a completely new start or major overhaul. Sometimes a designer must work remnants of a previous identity into a new and, hopefully, cohesive creation.

Such was the case for Emagic, a ten-year-old company that produces professional music production software and hardware. Among its clients are stars like Sting, Jamiroquai, Madonna, David Foster, and Herbie Hancock, but the company did not have quite so high a profile. In fact, its packaging faded into the background, especially on the shelf. Instead of boldly announcing the company as a confident specialist and market/technology leader for computer-based recording, its packaging had the typical, tired look of hundreds of software packages.

"Their claim of being the most advanced in terms of technology was not being transported visually through the graphic design," explains Rüdiger Goetz, a principal of Simon & Goetz, a Frankfurt, Germany–based brand and design consultancy.

But the client was not ready to give up its original logo: Its founders felt that redesigning their product packaging would be change enough for customers and employees. Leaving the logo as it was—at least for the time being—would give these people something secure to hold on to.

Emagic also wanted to communicate that it had a thorough understanding of the music scene today. (In fact, both of the company's founders are accomplished musicians.) The revised identity, to be promoted with a new package design that used the old logo, had to exude self-confidence.

Simon & Goetz's solution was to create a bold background of vertical stripes that can change in color for different applications. It is crisp and businesslike, but the multiple and varied colors give the packaging an appealing, human touch. The new design brings together the notions of creativity and technical excellence, says Goetz.

"The pattern is always different and changing," he says. "It looks like something you might see on one of the product's display screens, or it might be a technical, graphic representation of music or of creativity in general." It's also a homogeneous design idea that can easily be transported into all types of media in any combination of colors.

On top of the pattern, the designers placed blocks of product-specific information. Above that, in a pristine white area at the top of the package, sits the old logo.

"We created a clear space for the logo, where it won't be touched," Goetz says. "Our philosophy on this is, 'If you have to live with something that is so strategically and graphically critical, do not try to hide it, but put it right in the middle of everything.' The thickness in the letterforms of the logo and in some of the stripes match up in a nice way, for example."

The goal, says Goetz, was to create an empty space quiet enough for the logo to cooperate with the rest of the design. The approach works. "The logo is even more obvious in the new design than it was in the original design," the designer says. "Even though we would have preferred to redesign the logo, that step can wait until another time."

Design Firm	Landor Associates
Client	British Midland
Project	Corporate Identity

Blindfold a hapless airline passenger and seat him inside almost any aircraft or in any airline lounge, and it's likely he will not be able to identify the brand environment in which he is ensconced. Most airlines, points out Peter Knapp, executive creative director at Landor Associates, offer their customers a bland, undifferentiated experience. They all want to play it safe and are always looking sideways at each other, not wanting to step too far out of line.

> Landor Associates' work for bmi cuts through and commands attention. It stands out without being violent.

So when British Midland came to Landor in need of brand revitalization, Knapp saw an opportunity for the airline to break away from the pack and emerge as a stylish, relevant, and unique frontrunner.

British Midland had grown from a small domestic airline into a corporation beginning to offer trans-Atlantic flights. But even though the airline was flying all over Europe and to North America, consumers still viewed it as a domestic, or at best regional, carrier.

British Midland did have a lot going for it, however: an excellent reputation for being a friendly, welcoming airline—unlike the "stern headmistress" attitude many other outfits had—and for offering a more relaxed, elegant, service-based flying experience. The company wanted to expand its business and become a world player, but it was crucial to retain the softer, friendly aspect of its personality that had made it known and loved in the U.K. and Europe.

"[British Midland] is known for doing things well. What it offers is more like sailing and less like being in a powerboat," Knapp says.

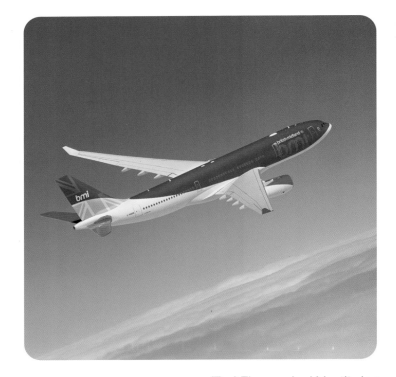

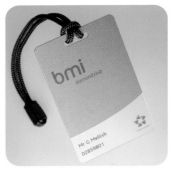

(Bottom) The elegant sailing curve is the only decoration this luggage tag needs. The quiet graphics embody bmi's message that theirs is the more pleasurable way to travel.

(Top) The new bmi identity is a smart mix of traditional British elements like the Union Jack and modern touches like the fresh color scheme and welcoming typography.

(Middle) By far the largest canvases for exhibiting the new identity are the bmi aircraft. Here, the soft, languid curve the designers call the *sailing curve* is applied to the entire craft, even in combination with the Union Jack on the plane's tail.

"Speed, with charm and style" became an essential part of the brand driver.

The color blue was also strongly identifiable with the brand, so the company wanted to keep that as well, though the designers were able to spruce it up into a brighter, fresher shade of blue.

Both Knapp and Simon Gregory, marketing director of British Midland, felt that the company shouldn't "throw the baby out with the bathwater." The brand had plenty of positive aspects that could serve the company well in the future, but a few things were holding back British Midland.

The company's name was one of the first things to be scrutinized. British Midland wanted its new identity to refer to the airline's distinguished history and speak to the future, too. The name they chose, *bmi british midland,* in lowercase letters, does both by retaining the former name but placing it in a secondary position, after *bmi,* which signals the advent of something new. Placing secondary emphasis on *british midland* also loosened the geographic tether on the carrier, which had begun serving international routes.

"*British* was fine, but the *Midland* part sounded distinctly regional," points out Gregory. The decision to go to an acronym was made quickly.

Next, the company's graphics were addressed. Landor conducted extensive research not only on customers' opinions of specific airlines and flying in general, but also on the lifestyles of bmi customers: which cars they drive, which hotels they prefer, which restaurants they frequent, which television shows they enjoy. As they interviewed people, researchers were looking for quality cues. What did they like best and why?

"We found that, increasingly, people appreciate style and design in their lives, and that there is a much greater appreciation of things like modern restaurants and international cuisine. The customer's lifestyle outside of the airport was increasingly motivated by design," says Knapp.

In airline parlance, style would have to be balanced with comfort, however. The airline's customers did not want an exaggerated experience, says Gregory.

"Flying had turned into such a feeling-less service, just functional and completely unemotional. It was surprising how resigned customers were to not enjoying airline travel. They had just given up," he says. "We had to be very concerned with that issue as people took longer flights and spent more time with bmi. Style and comfort had to be put back, but not so much so that it was over-the-top."

"Speed, with charm and style" became an essential part of the brand driver. Customers already knew that bmi offers plenty of flight options at competitive prices. What the graphics needed to communicate were the company's softer values.

For print and display graphics, Landor and bmi chose to celebrate unpretentious but well-known aspects of life in the U.K. Photos were shot not only in London, but also in Wales, in Scotland, and on the south and

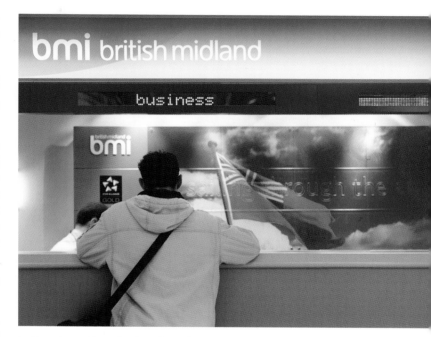

In the airport terminal and on the runway, bmi's identity system cuts through the visual clutter with a simple, friendly style.

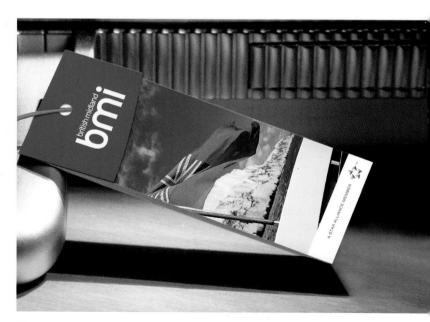

Photographs of British landmarks and cultural institutions are prominent in the bmi identity.

The company wanted to expand its business and become a world player, but it was crucial to retain the softer, friendly aspect of its personality.

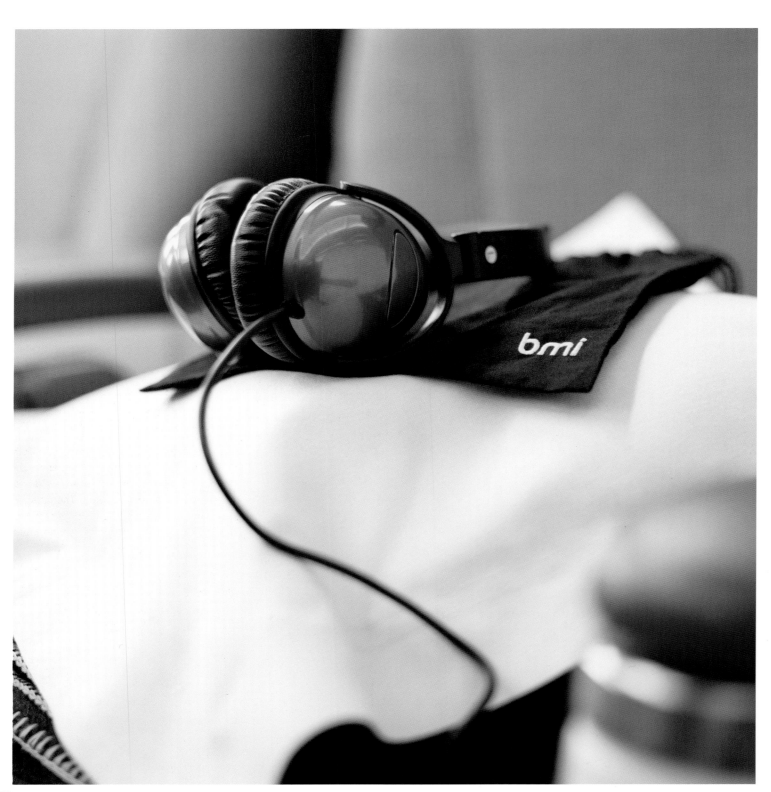

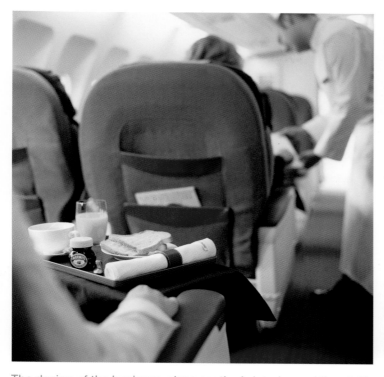

The design of the business-class section's interior and the staff uniforms also display elements of the rebranded identity.

east coasts of England. Images of the Mini car, a team of footballers having fun, greyhounds racing, and penguins in a zoo were used in combination with shots of classical architecture and gardens. The strongly British, modern photos actually stand in for the word *British* when the acronym *bmi* is used alone.

The familiar Union Jack was also brought in to identify the airline as a British company by imprinting it on each plane's tail. Instead of being blatantly patriotic and reproducing the flag in its true red, white, and blue colors, the designers decided to run it in a softer version of bmi's corporate blue. In the identity, red represents "speed" in the brand driver and is reserved for functional objects, like the planes' wings and fuselages.

"[The flag in soft blue is] almost like a watermark, like you would see on a piece of fine writing paper or on a piece of money. It implies quality very subtly," Knapp points out.

The third major graphic component of the new identity is what the creative team calls the *sailing curve.* This soft, languid curve of blue signifies leisure time well spent, and is the graphical opposite of rushing about.

"[The shape stands for] not being hassled, which so many people associate with the airline experience," Knapp explains. "The sailing curve is an expression of grace and dignity."

> ## The soft, languid sailing curve signifies leisure time well spent.

Since its rollout in 2001, the British public has welcomed the new identity, with 60 to 70 percent of the population making the switch to identifying the company as *bmi.* The company's staff has also embraced the new identity. And bmi's reputation for providing a pleasurable flying experience has been reinforced in the process.

Other figures that point toward success: the percentage shifts in brand association by the company's target audience pre- and post-rebranding. The number of passengers who see bmi as premier division airline is up 73 percent, while scores for exceptional service and looking after passengers well—areas that the airline already scored well in—are up 33 and 64 percent, respectively.

Whether it's seen on an airplane on the runway or on a sign in the terminal, Landor Associates' work for bmi cuts through and commands attention. It stands out without being violent. In short, it communicates understated British elegance.

Gregory says he believes his company's customers are finding that airline travel can be enjoyable. "We call it 'civilized aviation,'" he says, "which we define as minimizing the hassle, maximizing the pleasure."

City of Hong Kong
Identity Design

Landor Associates, Hong Kong, China

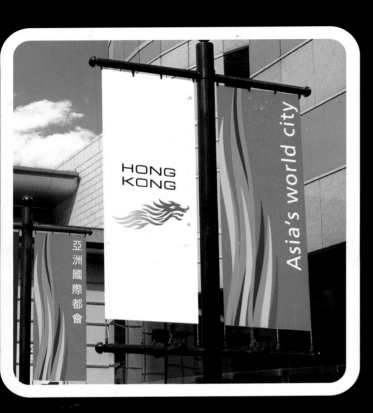

International location brand positioning: It's a relatively new concept that is starting to take hold around the world. In past years, and to varying degrees of success, Australia, the U.K., Canada, and New Zealand have initiated strong and recognizable national brand programs. When officials in Hong Kong decided it was time for their city to rev up its identity and become "Asia's world city," they turned to Landor Associates in Hong Kong for advice.

When the identity project started, the government, tourism board, trade development board, and other civic bodies were all using different icons, and this lack of coordination made it difficult to draw attention to the community as a whole. The client's only requests were that the new identity should be long-lived, visually appealing, memorable, practical, and easy to implement across myriad applications.

"Our goal was to create an evocative identity that would reflect the agreed-upon branding platform and be an accurate reflection of the Hong Kong brand," explains Michael Ip, managing director of Landor's Hong Kong office.

The designers explored a number of directions within the symbolic and typographic approaches, both abstract and literal. Five of these were subjected to consumer testing in key international markets. In the end, a dragon shape composed of the Chinese characters for *Hong Kong* and the English letters *H* and *K* was selected as the favorite concept.

"We did not specifically set out to create a dragon motif for the identity," Ip says. "Rather, we started by looking at the Chinese characters for *Hong Kong* to see how we could make them more meaningful and interesting. One early development was that the characters written in brushstroke Chinese calligraphy suggested a dragon."

As the mark was refined, the designers moved it away from being overtly Chinese and gave the dragon a more international flavor. They also added the visual suggestion that the dragon was flying in order to capture the dynamic qualities of the city.

The multiple colors in the multifaceted design play an important part in the image. "Anyone who has been here is struck by the diversity of colors, smells, structures, and experiences," says Ip. "We felt the colors capture some of those qualities you experience walking down Hong Kong streets, as well as reflect the energy of the place."

While the preferred brand signature includes only the dragon and logotype, the entire Hong Kong brand identity is actually composed of those two basic identity elements and the Spirit of the Dragon—the dynamic, multicolored "supergraphic" that looks like the dragon's fiery breath or flaming tail. The supergraphic can be used in full color or in outline format. Hong Kong has posted guidelines for the proper use of these marks at www.brandhk.gov.hk.

The citizenry's reaction to the new identity has been positive, and currently it is seen all over Hong Kong on banners, billboards, buses, trams, and ferries. Communities in and around the city have embraced the brand and are especially keen to use the symbol for their own promotion. Feedback from overseas, though hard to gauge, appears to be overwhelmingly positive.

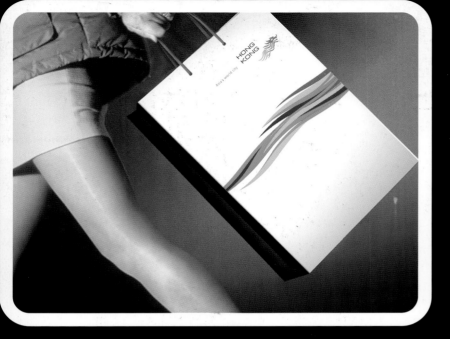

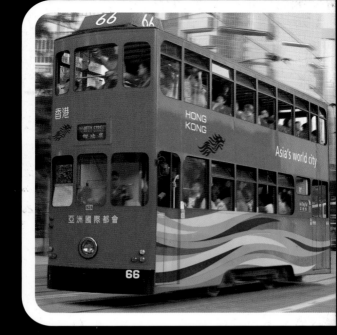

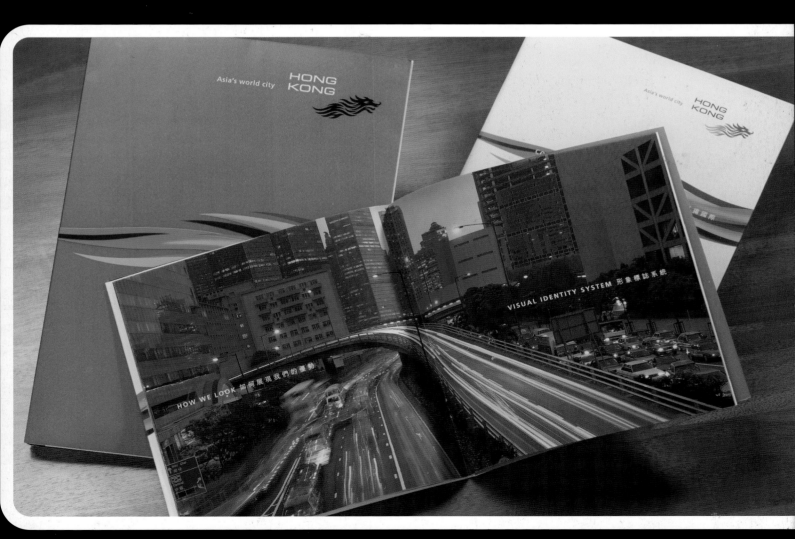

Design Firm	Cronan Group
Client	TiVo
Project	Corporate Identity and Naming

About two-thirds of the Cronan Group's business is naming assignments. And most of the time, the clients already know what they want, says principal Michael Patrick Cronan.

"Almost every time, the clients provide the answers. They just don't know that they know them," he explains.

When the developers of TiVo came to the Cronan Group with a revolutionary product in need of a like-minded name—the moniker Teleworld was being used as a placeholder company name—they knew they had something very different. The question was, how could they let consumers know that, although TiVo is a television-related product, this digital technology is as unlike regular TV as radio is unlike the Internet?

> Cronan says the impact of the main character won't be watered down by adding other little characters.

Teleworld—now TiVo—allows users to program their televisions so they can view what they want when they want to, without having to bother with videotapes. Instead, a large hard disk records and plays back the programs you like.

"But the real essence is not the hardware, it's the software," says Cronan. "It can go out and find out what you as a viewer like. For example, one of my kids was having a tough time with French Revolutionary history at school. My wife Karin [Hibma] went through TiVo to find shows about it and had him watch two shows per night until he had a better understanding of the subject."

Mike Ramsay, CEO of TiVo, brought Cronan in early and set the bar high, says Cronan. "I had worked with Mike on other large projects," the designer says. "He has a way of tossing a big challenge to you in a low-key way. When they gave me the corporate presentation, and my jaw was hanging open with the

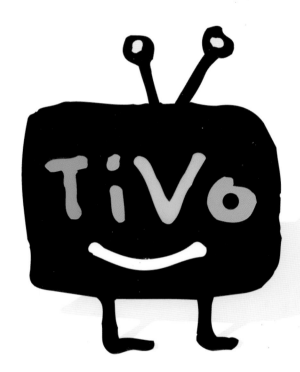

This impish character has become the personification of the TiVo brand: He wears his mantle with style. This version, created by the CronanGroup, was later further modified by Pittard Sullivan.

The TiVo character underwent a long period of exploration in the studios of the Cronan Group. This squib is what principal Michael Patrick Cronan calls a "preliminary and very lame letterform study."

But from the first letterform studies emerged this version, in which the designers discovered a face.

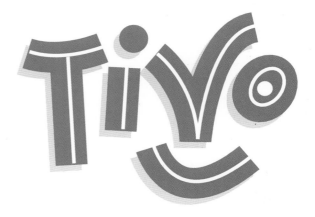

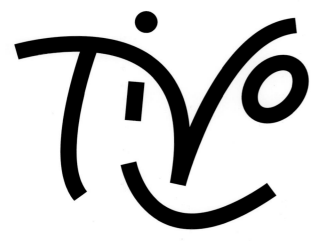

Here the face became more refined, and actually is very similar to the one in the final design.

"An attempt to give the letterforms more mass takes it in the wrong direction," says Cronan.

At this point, Cronan says, the team really got off track.

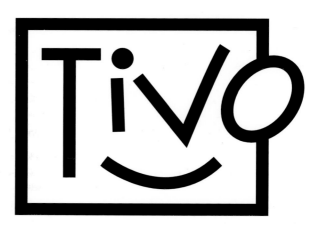

"Here," jokes Cronan, "TiVo goes undercover as a tech nerd."

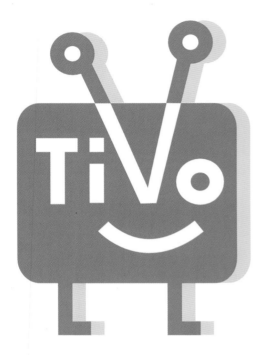

Finally, the design got back on track. The name was united with a strong, recognizable shape, but the designers felt that it was still too complex.

potential of the technology, Mike grinned and asked if I was up for 'helping them out a bit.'"

The idea was not so much revolutionary as evolutionary, Cronan adds. "When I realized that this technology would change the behavior of families, I was able to get the essence of the idea."

This breakthrough allowed Cronan and his staff to boldly move forward with the naming process. Usually, they generate eight to fifteen hundred names, then narrow that list down to about a hundred, and present those to the client. The final one hundred names circled around concepts like "capturing what you want, when you want it," "the way television was meant to be," and "TV your way."

The name TiVo came about when Cronan started thinking about the band Devo and how its music was a de-evolution of pop culture. TiVo sounds the same, of course, but the letters *i* and *o* also signify *input* and *output,* which neatly describe what users do: they input their wishes and output the results. And using the letters *T* and *V* clue consumers in about TiVo's function.

"TiVo was probably the eighth or ninth name we presented to them," says Cronan. "People in the meetings liked it, but it really wasn't a contender." He adds, however, that most clients don't recognize the right name when it's first proposed. Sometimes, patience is necessary.

Eventually, TiVo emerged on top. Now, Cronan started working on the product's mark. Cronan knows that people remember colors and shapes, so he began by considering which shapes would be the most discernible by consumers. What could be better, he reasoned, than the shape of a TV with a rabbit-ear antenna? Even children too young to be familiar with such low-tech devices intuitively understand the shape.

"I had been thinking about an image I'd seen of a Christian fish symbol that had been subverted by the placement of Darwinist feet below it. I thought, 'Let's put some legs on it—it goes out and finds things for you.' It actually is television with legs," he says.

Cronan created what he calls a very "simple and boneheaded" sketch, but knew that wasn't quite what he wanted. That's when he began talking with the design firm Pittard Sullivan about the nature of the character.

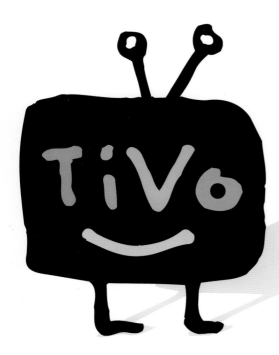

This squib is the first official profile of the TiVo character, which later was redrawn by design firm Pittard Sullivan.

> "Almost every time, the clients provide the answers. They just don't know that they know them."

"[The animated character] they came up with really freaked me out at first," Cronan recalls. His static character, which had had its toes stiffly pointed to the right and its antennae sticking straight up, had become much more friendly by pointing his toes and antennae outward in a jauntier demeanor.

That redesigned character is like a friendly imp or spirit. Cronan says it reminds him of a happy genie in a bottle.

"Typically, technical [product] people want their identity to look slick. But the largest population of people using TiVo consists of young people and families, so the idiom of the cartoon character indicates that he is friendly and not complicated," the designer says. On screen, the TiVo character moves all the time, tipping his head, moving his feet, and smiling all the while, as though he is patiently waiting for the user to make a choice.

Cronan predicts that the character will continue to evolve. He anticipates that, like Mickey Mouse, the TiVo character's basic shape will be identifiable in all of the permutations it's likely to go through in the future. Cronan says the impact of the main character won't be watered down by adding other little characters.

One important lesson Cronan says he learned from the TiVo project was that a particular sort of client/designer relationship is more effective for his team. The meetings with the TiVo developers, he says, were always fun and jovial, and as any designer knows, those gatherings can be frustrating and tense. "Our relationships with other clients have been affected," Cronan says. "Before we really get to work, we want to get the client smiling and laughing."

Credits

Creative and art director, designer, name and identity: Michael Cronan
Animated character design: Pittard Sullivan

Kintana
Identity Design

Cronan Group, Emeryville, CA

Kintana is an identity that was developed to be like an empty vessel, explains Cronan Group principal Michael Patrick Cronan, waiting to be filled with the essence of the company's good reputation and fine products. Unlike the concrete TiVo identity Cronan also developed, the Kintana logo is abstract, but both are successful.

Cronan's client, a company previously named Chain Link,

standpoint, only asking for a logo that was bleeding would be worse. I knew, though, that he wanted something that had a lot of power and courage," Cronan says.

After extensive name research and testing, the company was renamed Kintana, a nebulous moniker, but one with the right sensibility. Cronan found the perfect alternative to an exploding logo by taking the letter K and

develops software that large companies use to search their computer systems to make updates; the utility even suggests better software options for the company's data processing needs. The very nature of the business suggests change—which Cronan acknowledges that most people find painful—and the identity his team created needed to point away from that.

When Chain Link came to the Cronan Group, it was a successful company, but its founder, Bryan Plug, wanted it to develop the cachet of an even larger company. Cronan worked very closely with Plug to help the keeper of the company's vision relax and communicate his innermost thoughts on the new identity; that's key, says Cronan, to any project's success.

Plug requested that the designers come up with something unusual, Cronan reports, something that he wouldn't expect them to. "Actually, he wanted the logo to explode—from a designer's

twirling it 180 degrees in Adobe Illustrator. "This created a pattern that reminded me of a hurricane," he says. He also turned the A's into arrows pointing up. Strong, angular letters like the N, T, and K gave the mark good bones.

Is there a danger in creating such an abstract logo? Cronan notes that logos do not live in a vacuum. He calls his job "culture building," and says memorable logos set the stage in which companies operate.

"What kind of company are you going to have?" Cronan asks rhetorically. "Are you selling widgets or are you selling really innovative and reliable widgets? Does the company have the resources to put the brand forward and make it stick? If so, an abstract logo can be very memorable. Context has to be the judge of any logo's success."

Credits
Creative and art director: Michael Cronan; Designers: Michael Cronan, Dan Stiles

KINTANA™

Phone 408.543.4400
Fax 408.752.8460
1314 Chesapeake Terrace
Sunnyvale, CA 94089

www.kintana.com

Bryan Plug
Chief Executive Officer

Direct 408.543.1119
Fax 408.752.8460
Mobile 408.111.0001
bplug@kintana.com

1314 Chesapeake Terrace
Sunnyvale, CA 94089

www.kintana.com

KINTANA™

www.kintana.com

KINTANA
1314 Chesapeake Terrace
Sunnyvale, CA 94089

KINTANA™

Design Firm	Cato Purnell Partners
Client	Channel 7
Project	Corporate Identity Redesign

Television was introduced to Australia in 1956, just in time to cover the Melbourne Olympics. There were three channels at the time: 2, 7, and 9. After years of competition and many identity changes, Channel 9 emerged as the ratings winner just prior to the Sydney-hosted Olympic Games in 2000, and runner-up Channel 7 decided it was time for an identity makeover for the Games and the new millennium.

The station called in Cato Purnell Partners for help. When the design firm began working with the client, Channel 7 was using a red numeral 7 with a circle around it as the main element in its identity. Trouble was, this was an unremarkable mark that was identical to ones being used in the U.K. and the U.S.

> "And I did look at every type book on the planet, looking for the best-looking 7."

A secondary element in the identity was a color bar of five colors, originally added to the identity to signify the advent of color TV. That was an outdated symbol, though, because all television stations broadcast in color today.

Nevertheless, the client wanted the bar in the design. "When I was introduced to the project, the job seemed very straightforward to them," recalls principal Ken Cato. "They said, 'Put [the number and the bar] together, and what are you going to do with the 7?' And I did look at every type book on the planet, looking for the best-looking 7."

About a week before the presentation, Cato still hadn't found a numeral seven that really stood out. Then he had a *eureka* moment.

"I have a habit of making scribbles on pieces of paper—I tore a strip of paper into the basic proportion of the color bar and told someone, 'It needs to be as simple as this.' Then I folded the strip at a forty-five-degree angle, and that was it," Cato says.

Australia's Channel 7 is widely recognized across the country by this very simple, yet dimensional shape.

When television was introduced to Australia in 1956, there were only three channels. Channel 7, the Australian Television Network, was one of them, and this was its logo at the time.

In 1956, a more modern, distinctive mark was developed.

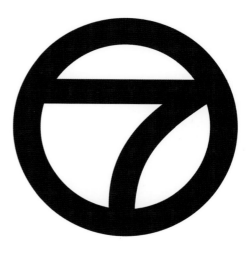

The folded-ribbonlike 7 centered in the circle was also used in other iterations in the 1950s.

Then, in 1966, this strangely distorted logo was introduced. Unfortunately, it was very similar to a mark being used in the U.S., and the network wanted their mark to be unique.

This bold 7 in negative is from 1975.

This is yet another variation on the logo from the mid-1970s.

> **That moment was satisfying, Cato says, but he knew that it was the start of the solution, not the end.**

That moment was satisfying, Cato says, but he knew that it was the start of the solution, not the end. The next step was to develop a language that would support and surround the new trademark.

"Trademarks need a broader visual language today, something that makes one so recognizable that even when the trademark is not there, everyone will recognize [what] the company is," Cato says.

In the case of Channel 7, the broader visual language related to the station's early claim of being the first in Australia to broadcast in color. Cato extended the use of color far beyond the original identity's ribbon. In one instance, as the movie *Top Gun* aired, five small airplanes, each one a color in the identity's color bar, appeared in the upper corner of the screen. Five flowers with those colors appeared in a gardening show. With identity markers like these, it is clear to viewers which station they are watching even when the newly designed icon doesn't appear.

"What supports a trademark is so important," Cato says. "A trademark does shorten the time to recognition, but most of us still don't have time to get to the next page of a Web site or go to the bottom of a brochure. Unless you are right there when the logo is shown, you miss it."

Another problem with logos today, Cato contends, is that competitors in a market sector look so similar to one another. A good example, he says, are athletic shoe and apparel companies: As soon as one brand does something, the others follow. Cato recalls seeing what he believed to be a Nike commercial on TV, but when the spot concluded, it was actually an ad for Adidas.

"It got me wondering where it all is going. The space we are occupying is so crowded. Unless you are communicating all of the time, then you are probably not being recognized," he says. "We have to find better ways to fill the time frames we are allowed to work with these days. This doesn't mean that the trademark is obsolete; it just limits its usefulness."

Channel 7's new identity continues to be played out in new and different ways. For instance, the Christmas card the broadcaster sent to its colleagues in 2001 pictured "seven swans a-swimming," each one of a different color. Recipients did not need to see the logo to know whom the card was from. According to research, viewers find this kind of play and experimentation with color warm and friendly. And perhaps that has something to do with the fact that, at this writing, the station is in the top slot for ratings, for the first time in its history.

This logo, from 1989, was designed so it could be animated to move on TV (left) or work in a stationary format (right).

Cato insists that the experimentation with and study of Channel 7's logo must continue.

"In a meeting with the client recently, I asked everyone there, 'Where is Channel 7 on your remote control at home?' Some said at the 5 button, others said 3. It made them all rather uncomfortable. Then I asked, 'So how relevant is the brand of 7?' When you had an analog TV dial with numbers on it, it was easy to find the 7 brand. Today, on a digital system, Channel 7 might really be 55 on the dial. That shows that we have to build in the ability for a trademark to change over time. There need to be such things as

brothers and sisters and even distant cousins to the current logos as the business continues to change."

In the future, Cato believes, it will be more and more difficult to establish a solid trademark. Huge amounts of money will be needed to penetrate the consumer psyche. The logos that do succeed will be highly valuable. And while such a trademark will be valued, other parts of an identity may be even more valuable. "Like with Channel 7," Cato offers as an example, "the ribbon ended up being the most potent identifier."

"We have to find better ways to fill the time frames we are allowed to work with these days. This doesn't mean that the trademark is obsolete; it just limits its usefulness."

Deep Fire Productions
Identity Design

Cato Purnell Partners, Melbourne, Australia

Above all else, an identity must be appropriate for the business it represents, says Ken Cato of Cato Purnell Partners. But identities must also say something meaningful about the business, be memorable, and be practical so, for example, they can be reproduced across a wide range of media, from broadcast TV to signage, from metal engraving to pencil imprinting.

"Unless you've got those things, a trademark or identity won't succeed," he says.

But when a designer actually achieves all of those imperatives, it's possible to strike an emotional resonance in viewers. This was the case with Deep Fire Productions. The company's owner, an intellectual and writer, had decided to start producing videotapes and films.

"He is deeply passionate about what his company does," says Cato. "The symbol I chose for him becomes obvious once you know that." It was a flaming heart.

The client's reaction was remarkable. "In the presentation, the client actually began to cry," Cato recalls. "'You have captured what we do exactly—this is exactly who we are,' he told us."

The designer didn't restrict the concept to just the trademark: A portion of the company's letterhead seems to have been burned away. The first sheet to be used in a communication has what looks like a burned corner and a singed area in the center of the sheet. Subsequent sheets have an apparent scorch mark on them in the same location as on the top sheet.

The beauty of the identity mark, Cato says, is that the flaming heart can literally be interpreted as the symbol of the business while it also expresses the emotional involvement of its owner and the commitment essential to any creative endeavor.

Design Firm	Chermayeff & Geismar, Inc.
Client	Toledo Museum of Art
Project	Identity Redesign

A public art museum can easily lapse into ordinariness. Many cities have them, and of course, they all contain works of art. Few of these buildings have enough of an identity that a museum patron led blindfolded into the galleries would be able to identify the museum once the blindfold was removed.

To thrive, art museums must be able to host major shows and secure loans of specific works. Facilities without a strong identity might seem to lack credibility, and could find it harder to attract the more prominent works that bring in the crowds.

Facilities without a strong identity might seem to lack credibility.

These were the challenges facing the Toledo Museum of Art in Toledo, Ohio, which invited Chermayeff & Geismar, a New York City design firm, to remake its image. "There had to be something we could do to make people understand that this museum was in Toledo, not in Birmingham or some other place," explains Steff Geissbuhler, designer, partner, and principal at the firm. "The place needed a specific character that could be played out through all of the facility's signage, advertising, stationery, everywhere."

The designers began by studying the museum's name. They knew early in the process that they did not want to use the acronym that the client was using at that time, TMA. It wasn't memorable and had never become part of the patrons' vocabulary, so the decision was made to return to using the full name, the Toledo Museum of Art.

Next, Geissbuhler studied the city of Toledo and its art museum. What made them special and distinct? From long experience in creating identities for public and private facilities, the designers at Chermayeff & Geismar already knew that they had to speak not just to the people of Toledo, but also to patrons from around the world who would likely know little about the city. It was crucial, then, to encapsulate the defining characteristics of Toledo in the museum's identity.

The Toledo Museum of Art's logo frame is meant to be a symbol: Even though the museum's name appears on it, the logo's creators at Chermayeff & Geismar would rather the frame be recognized as a shape that represents the museum. The teal color was borrowed from the museum's oxidized copper roof.

Another important consideration during the design process was that they did not want to create an identity that dated itself or confined itself to a certain art movement.

Steff Geissbuhler and his design team like to show clients the logos and identities they create in context. This selection of application comps shows some of the ways the new logo could be used.

After extensive research, Geissbuhler discovered that if people know anything about the city, it's that Toledo is a center for glass production. In fact, the museum has a huge glass collection, and local glassmaker Libbey Glass is one of its main backers. An all-glass building to house the museum's glass collection is planned for a site across the street from the main building.

"So thinking of glass and its see-through nature was very much a part of our thinking while we created this identity," Geissbuhler says.

Another important consideration during the design process was that they did not want to create an identity that dated itself or confined itself to a certain art movement. The museum has a very good, though small, collection, Geissbuhler says, but the new identity was not meant to describe or define it. Any graphics he created, then, had to focus on the museum's sense of place and avoid any historical context.

The concept of using a frame to symbolize the museum emerged from all of these considerations. A frame can be seen through, like glass, and often holds glass as well as an image inside it. For a museum at which a specific art form is so prominent, the symbolism seemed appropriate to the designers. And just as frames display items of monetary worth and cultural value, so, too, do museums.

"We liked that the frame could be more than some simple symbol or graphic, and we felt that people would easily learn that the frame stands for the museum in any application," Geissbuhler recalls. "The frame is really the essence of the museum. It is a symbol for framing pictures, and it is also a way of showing transparency. Whether you are seeing through its opening, or seeing something framed by the box, you are looking into the identity and interacting with it."

The frame element also offered a practical advantage: It could easily accommodate the museum's rather lengthy name.

"This was a way to keep the name from being too cumbersome or wordy by incorporating it in a symbol that would be recognizable without ever reading the name," the designer explains.

These are some of the products that have incorporated the logo in their packaging since the new identity was launched in 2000.

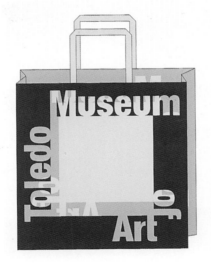

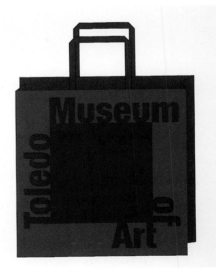

The name was placed on the frame so that it is read in the clockwise direction. It also was made to bleed to the inside edge of the frame, uniting the words with the image inside the frame. It's crucial, Geissbuhler says, to always keep in mind potential applications for a logo while it is being designed so it will work in multiple presentation formats. In fact, rather than just presenting an isolated logo to a client, the Chermayeff & Geismar designers always show it in the environments in which it will be used.

"You have to show them the potential of the piece," says Geissbuhler, "how it can evolve into something else, like signage, or a banner, or an ad."

In application, the frame element is very versatile. It can be used as a simple box with an opaque center, or its center can be made transparent to let color or art show through from behind. The item framed can be a collection of samples of art from different shows or collections, or a highlight of a detail from a larger image. It's also used to frame the names of other museum entities and to display special logos, such as the one designed for the museum's one-hundredth anniversary.

As a purely graphic form, the frame has a strong impact. Whether it is emblazoned on a sign mounted on a steel blade or crafted as a diminutive, silver lapel pin, its solid edge and blocky lettering pull the viewer's eyes toward its center.

Geissbuhler says that although the frame element would work as a symbol for any art museum, he feels that it is especially fitting for the Toledo art museum, with its many educational exhibits and connection to glass. The frame, and the museum, invites people to come in and learn.

"There are schoolchildren all over there," Geissbuhler says. "Kids can try on Egyptian clothes and write hieroglyphics. There's a ceramics building where you can throw a pot and a place where you can blow glass. A theater is part of the museum campus, as is an art school. Students and artists are everywhere. "That's what's unique about this place. What we created for the museum has legs—it should be able to evolve and be pushed."

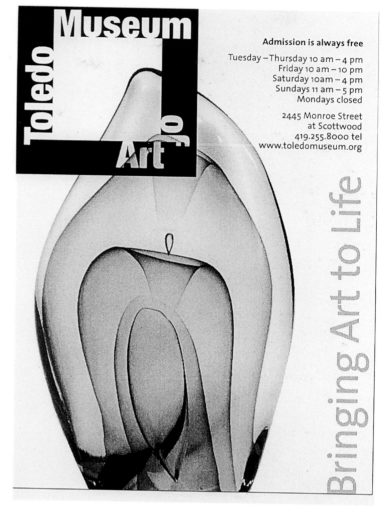

Credits

Design: Steff Geissbuhler, principal

American Cinema Editors
Identity Design

Chermayeff & Geismar, Inc., New York, NY

"A logo," says Steff Geissbuhler, designer, partner, and principal at Chermayeff & Geismar, "is really only the cornerstone of a visual identity program. It is the visual language which evolves from and with it that makes the name and identity memorable."

This was the premise that Geissbuhler presented to his pro bono client, the American Cinema Editors, prior to creating its new identity. The logo solution the design and brand strategy firm eventually presented to the ACE was just a start, but it certainly got that group set in the right direction with the proper tools for the trail.

As he developed concepts for the client, Geissbuhler focused on the essence of film editing in the larger sense of the term—making choices, putting pieces together, adding and deleting, making a whole out of many fragments. At the same time, the designer wanted it to be clear that ACE's members are film editors, not literary or some other sort of editors.

Geissbuhler recommended two different solutions. The first was a three-piece logo created by German designer and intern Christian Butte. The playful collage of letters as images on pieces of film was to the designer a direct way of visualizing the editing process in an abbreviated and abstract way. The acronym is literally pieced together to form a whole.

The second solution, the one that was ultimately chosen, takes full advantage of the shape of the capital letter *E*—the most important letter in the acronym, according to the designer—which has what look like sprocket holes on its right side, in the spaces between the horizontal lines. Geissbuhler then added sprocket holes along the left side of the logo to simulate a strip of film.

Inside the mark's frame, the acronym *ACE* is cut approximately in half at the top and bottom, depicting only one full frame with the acronym at the center. This implies multiple frames and rolling credits. The logo has the advantage of being able to bleed off of edges. It can also repeat as many times as desired, which gives the illusion of motion, and therefore motion pictures, in a very simple and abstract way.

When Chermayeff & Geismar designers present identity work to clients, they first apply it to a range of comp designs to give the client a context in which to see the work. For the ACE, the logo was printed on letterhead, envelopes, business cards, membership cards, promotional apparel, and posters.

"The applications demonstrate that this logo can be used with or without the full name, based on context and audience," says Geissbuhler. The designers are also exploring the possibilities of extending the visual language of the identity: Adding a few prefix letters to the logo creates strong words such as *place, face, embrace,* and *lace.* This pulls the identity out into even more iterations for application to posters, postcards, mailers, T-shirts, and more.

The client chose the rolling-credit logo because it clearly depicts film rather than still photography. It suggests motion and the splicing and cutting of the editing process. It also relates to ACE's slogan, "Visible Art, Invisible Artist," by depicting the one place—the rolling credits—where film editors often get their only thanks.

Geissbuhler says that the logo, which was implemented at the start of 2002, is a good solution because it is simple. "It is memorable, appropriate, very workable, single-color economical, clear, and timeless. *ACE* is such a strong and meaningful acronym that it deserves a strong visual representation," he explains.

Design Firm	Minale Tattersfield & Partners
Client	Express Dairies
Project	Corporate Identity

U.K.-based Northern Foods PLC originally had four divisions: Dairy, Convenience, Meat, and Grocery. In the Dairy division were the six dairy-related companies in its holdings: One sold milk products to supermarkets; one handled delivery and distribution; one sold milk at small outlets; another sold dairy products exclusively in Ireland; and yet another sold milk by-products such as curds and whey to food manufacturers. The sixth company, Express Dairies, offered doorstep delivery of dairy products throughout the U.K.

> "This coming-alive look of the brand is synonymous with the company's future aspirations."

But in 1998, when Northern Foods PLC demerged the Dairy division into a separate PLC—the largest demerger the food industry had seen to date—the newly independent group was faced with an identity quandary. Each dairy-related company had had an excellent reputation under Northern's umbrella and wanted to preserve it. But the group as a whole needed a new identity under which to gather, an even stronger brand that unified all six pieces.

The international design strategy group Minale Tattersfield & Partners was called in to help, first to formulate a brand identity strategy for the launch of the new company, and two years later, to modernize the brand for the future.

The first step was to create a unified brand that built on the strengths historically connected with the Northern brand. For this, of course, a new name was needed.

Express Dairies was established in 1864, so it had plenty of history. Its daily deliveries, whether done by train or other vehicles, had been a common sight in the U.K. for over a hundred years. After much consumer and marketing research, Minale Tattersfield recommended that Express Dairies be retained as the umbrella name for the group.

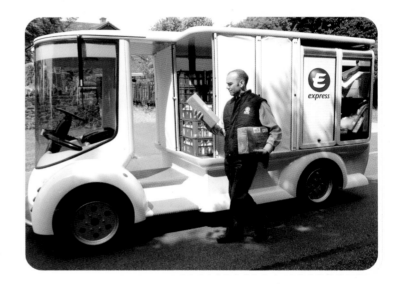

(Top) Express Dairies' new identity not only brought the company into the twenty-first century, it will also allow the company to expand its service offerings to customers. In the future, Express plans to deliver not only dairy products to the home doorstep, but also packages.

(Middle and Bottom) The new logo has a double life: It works as a strong identifier for dairy-product packaging, and has also come to represent the package-delivery component of Express's business. The milk "floats," or delivery trucks, have been repurposed to deliver both milk and packages.

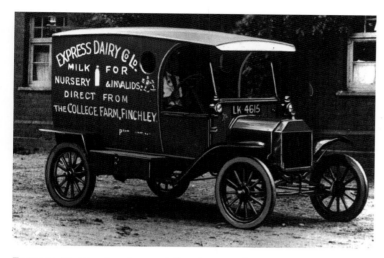

Express Dairies has been delivering quality products to its customers for over a hundred years, as this photo from 1882 attests. The company has long held a meaningful position in consumers' minds.

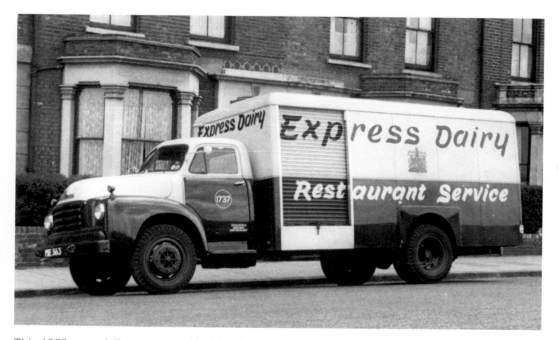

This 1950s-era delivery van and bottle of cream reveal the company's first use of the brush-stroke *E* that formed the centerpiece of the new brand graphics.

"In the end, we changed the shape and the space and pace of the identity and just called it Express."

GROCERY MEAT PRODUCTS CONVENIENCE FOODS

These diagrams show how Northern Foods was structured before its Dairy division was demerged (top), and how the Express Dairies brand was structured afterward (bottom).

Dairy Operations

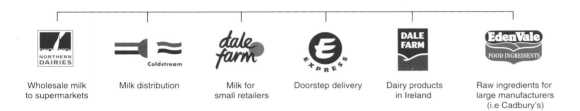

Wholesale milk to supermarkets Milk distribution Milk for small retailers Doorstep delivery Dairy products in Ireland Raw ingredients for large manufacturers (i.e Cadbury's)

Express Dairies Milk Food Service Express Dairies Distribution Express Dairies Own Brand Partnership Express Dairies Endorsed

"This is not the place for humor. Milk needs to offer total assurance."

In this 1964 product shot (above), the *E* is taken one step further in the design: It is isolated as a circled element and given more prominent positioning. Today, as seen in the current products (right), the design has remained with only a slight alteration to the font below the circle.

"You don't want to throw the baby out with the bathwater," explains Alex Maranzano, a partner at the design firm. "In the end, we changed the shape and the space and pace of the identity and just called it Express."

The biggest danger when creating a new brand for an existing company, Maranzano adds, is creating something so new that consumers don't recognize it and lose confidence in it. So the challenge is not only to build market share, but also to retain the advantage the client's history has already given it. Even a momentary dip in consumer confidence can mean significant losses for a company.

The new identity needed to appeal to a dual audience: markets, which buy enormous quantities of product, and consumers, who purchase Express products one container at a time.

"They needed to feel that this was a serious entity, not something that just arrived," notes Maranzano, who adds that when it comes to food products, consumers need to have plenty of continuity and therefore reassurance that what they are putting into their bodies is safe. "This is not the place for humor. Milk needs to offer total assurance."

Express's main competition comes from Dairy Crest. Both companies are very similar: Each is large, can supply markets and consumers with the products they want to buy, and emphasizes the freshness of their products, which are turned around from farm to store shelf in twenty-four hours.

With such similar offerings, the new identity and packaging would have to work hard to differentiate Express's offerings. But just looking different

would not be enough. For instance, another competitor was using a compilation of black-and-white photos of people for its milk carton packaging design, presumably to depict a lifestyle.

"I find this packaging very confusing," says Maranzano. The products no longer looked like food products, they looked like software packaging or something purchased from a clothing shop. With food products, it is important not to stray too far from consumer expectations, Maranzano notes. "Color is also a very important part. Blue belongs to Express. When people see a milk jug with a blue-and-white stripe on it, they know it is from Express. It also implies coolness and freshness." Competitors Dairy Crest and Unigate use a green-and-yellow and a red scheme, respectively.

The centerpiece of the new Express identity was also pulled from familiar traditions. Since the 1950s, the public had seen the name Express Dairies in brushstroke letters on milk delivery vans. Then, in the 1960s, the wordmark was updated and the *E* in *Express* was placed inside of a circle.

"The 1960s update of the brushstroke version is very Swiss Graphic in style," says Maranzano, of its clean, mechanical nature. "We have taken the two-dimensional *E* inside of a flat blue circle and created a modern 3-D version, implying a more universal, far-reaching company working day and night. This coming-alive look of the brand is synonymous with the company's future aspirations."

Minale Tattersfield's designers believed that the identity should be evolutionary and not revolutionary. Having established the name's continuity,

The logo as it appears today in a number of uses. It has a 3-D quality that its predecessors did not have.

EXPRESS PENSION SCHEME
INTRODUCTORY LEAFLET

Stands out from the Crowd

Express Dairies plc
March 2001

EXPRESS
PENSION SCHEME

Your Pension
and related Benefits

Express Dairies plc
March 2001

EXPRESS
PENSION SCHEME

Additional Voluntary
Contributions

Express Dairies plc
March 2001

HEALTHCARE PLAN

Member's Handbook

Express Dairies plc
March 2001

the group proceeded to create a series of designs with varying degrees of differentiation from the existing symbol. At the same time, market research was conducted to discover just what consumer awareness of the Express Dairies brand was.

That the brand scored very high with consumers made what to do clear to the designers: With hundreds of *E* symbols out in the marketplace already, Express's unique letter shape had to stay true to its origins to retain its high recognition factor.

Express Dairies' owners wanted to allow for future development of the brand, so the identity could not be specific to just milk or dairy products. One plan that has since been implemented included using milk floats (delivery trucks) to deliver diverse products—usually purchased over the Internet—to homes.

Maranzano says that it simply made sense to repurpose the vehicles because they were already making door-to-door deliveries. The name *Express* and the logo's progressive-looking, forward-leaning *E* work equally well in identifying this new line of business.

"Originally, 50 percent of the milk in the U.K. was delivered to people's homes," he says. "Now just 20 percent is, so the floats can be used to deliver other products."

That the new identity has been well received despite the recent outbreaks of BSE and foot-and-mouth disease is in itself a huge victory, says Maranzano. With the industry as a whole suffering because of these terrible events, he adds, the solidarity and freshness of the identity reassure the consumer that Express continues to evolve and improve.

Royal Armouries Museum
Identity Design

Minale Tattersfield & Partners, London, U.K.

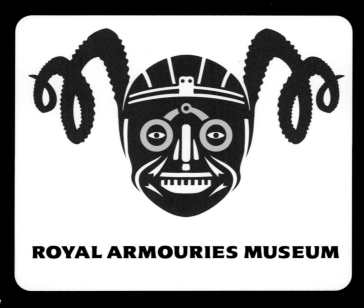

ROYAL ARMOURIES MUSEUM

Within the Tower of London, there lay a vast collection of armories and war artifacts. Some items were on display for the public's view, but many thousands of the items stockpiled by the monarchy had not been seen for centuries. To allow the interested public to see and learn about the entire collection, the Royal Armouries Museum was built in Leeds.

Minale Tattersfield & Partners was called in to create identity, signage, merchandising, and communications systems for the new museum, which opened in 1996. The client asked principal Brian Tattersfield, creative director Alex Maranzano, and their team of designers to produce graphics for what was planned to be an interactive experience.

Tattersfield and Maranzano had the opportunity to view some of the extraordinary objects that would be on display.

"We came across this mask, a quite spooky-looking thing, that was made for Henry the VIII by the court armorer of Maximilian I. It looks like it was intended to be used for attacks [in war], but in fact it was used for his protection," explains Maranzano.

The grotesque horned helmet was all that remained of an entire suit of similarly styled armor. Its blank eyes were wild, and its fierce face spoke of everything from the horrors of war to the thrills of the tournament field.

The creative team knew that the face—with its striking appearance and storytelling abilities—would make an ideal centerpiece for the Royal Armouries Museum's new identity system. Coincidentally, the museum's initials, RAM, also spelled out the name of the animal the mask represented. It was the perfect match.

The designers simplified the ornate mask image into a more stark, graphical symbol that could be used in a range of applications from museum displays, banners, and signage to merchandising items, promotional literature, and stationery. The new symbol, so striking even at first glance, was an immediate hit with museum patrons. And despite the fact that it is indeed a scary visage, the mask especially seems to appeal to children. Maranzano attributes this to the inherent interactivity of a mask: It appeals to their imaginations.

The creative director says that the identity is certainly an illustrative one, in the tradition of solutions created by Bob Gill and Lou Klein in the 1960s. For a museum filled with artifacts too curious for most modern-day people to imagine, an illustrated identity is an ideal solution, he says, because it draws a much stronger response from the audience than a simple symbol would.

"It is the visual manifestation, literally and conceptually, of what is inside the museum," he adds.

Design Firm	Sandstrom Design
Client	Kombucha Wonder Drink
Project	Product Identity

What's the best way to inform consumers about a new beverage variety they've never heard of or tasted? Should you build an identity that describes in detail in its name and packaging the product's taste and benefits? Or is it better to only allude to these qualities through type and design, then offer no additional clues at all?

In the case of Kombucha Wonder Drink, the latter approach held sway. Sandstrom Design, working with the creator of the beverage, an experienced tea purveyor and bottler in Portland, Oregon, chose to leave a new drink product almost entirely unexplained in its identity and marketing. Then, they reasoned, curious consumers would be forced to figure out Kombucha for themselves, thereby becoming much more involved with the brand. It would become the choice for people who were really "in the know."

> The goal throughout this process was to make the design a bit hard to place.

Traditional Kombucha (pronounced Kume-BA-cha) is a naturally fermented black-tea drink popular in Asia and parts of Europe for its reputed health benefits. "Kombucha: A culture brewed in Asia for 5,000 years. Villagers don't have health clubs. They have this," reads one block of sales copy. The new product was designed to appeal to health-food fans, baby boomers interested in their health, and people who aren't averse to new ideas and products.

"We designed it to not look like anything else available—not a tea, not an energy drink, not a soft drink, not an alcoholic drink. It's supposed to be very mysterious, so the buyer can't even imagine where it comes from," explains Rick Braithwaite, president of Sandstrom Design, Portland.

Prior to concocting Kombucha Wonder Drink, the drink's creator, tea enthusiast Stephen Lee, had years of experience in the beverage market. He had watched another bottled Kombucha

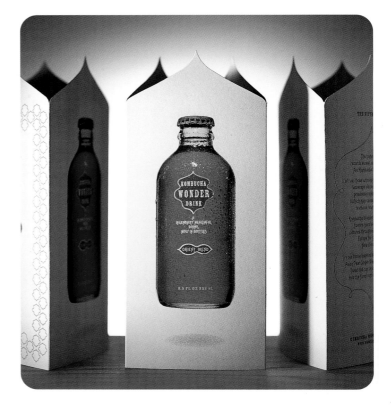

(Top) Kombucha is the drink from nowhere and everywhere. It has an ancient history, and it's the very latest thing, all at the same time. Sandstrom Design packaged its client's green- or black-tea-based beverage in a way that makes the consumer seek it out, as opposed to the product trying to attract the consumer.

(Bottom) These table tents give off many design cues: Minaret rooftops and mosaic tiling suggest the Middle East, while the typefaces seem both European and Asian at the same time.

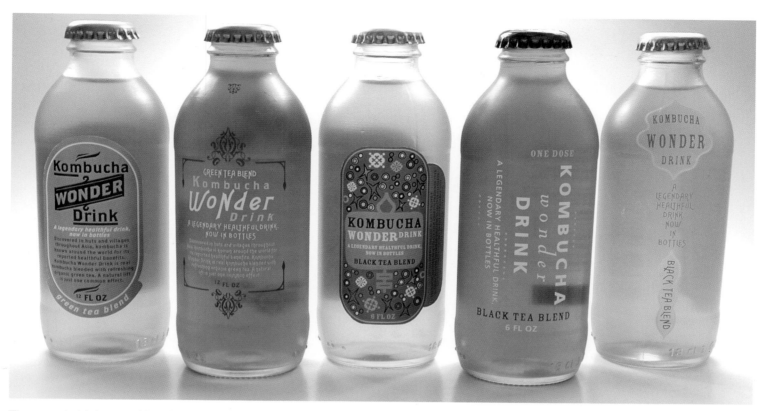

These early trials reveal just how many personalities the product tried on for size during the design process. Some were too contemporary, and some told too much about the product.

"We didn't want it to compete with bottled water or tea or beer or any other product. We needed to keep it a little mysterious and unknown."

product be introduced and then fail, but he felt that, with just the right identity, he could make the product a success.

Sandstrom Design began by naming the new drink. Braithwaite recalls that they considered a number of campy names such as *Bucha, Vicha, Continental Kombucha,* and *Hans and Young Li's Fabulous Kombucha Drink,* but in the end, they concluded that the name Kombucha was important and should be given primary emphasis.

"For those who are already familiar with Kombucha, why hide what it is?" he asks. "For those who don't know what it is, it sounds foreign, but who knows where it's from. Plus it's just a fun name to say."

Wonder Drink had its own appeal. "It's a wonderful understatement, but in a clunky way. It had an intentional lack of sophistication that made it seem all the more believable," Braithwaite adds.

With the name agreed upon, design of the product packaging began. Braithwaite says the goal throughout this process was to make the design a bit hard to place. A number of designs were comped up. Because Sandstrom presents all of its logo designs to clients in context, in this case, they prepared mocked-up bottles. A logo that's designed for a bottle is out of context when it's plopped on a piece of paper, they believe.

A number of comps were presented: One version had contemporary design cues and looked a bit like a bottled-water product. "You would know what that one would taste like before you even tried it," says Braithwaite. Another design was more apothecary-like, as if it came from an old drugstore. It was deemed "too Midwestern," expected, and geographically specific.

There are no cues in the design they ultimately selected that point the mind toward a specific country or culture. Nor are there nods toward other beverage products on the market.

The Kombucha Wonder Drink company's stationery carries on the brand's mysterious identity, combining clean and contemporary styling with a hint of age.

This brochure is a consumer flyer used at the retail level. The diecut piece is a shelf talker, also used at retail. Rumor has it, says Rick Braithwaite, that the talker is being stolen by teenaged girls and used as a bracelet.

These mailers were sent to distributors, major retail chains, and other potential channel partners to show the product and provide background information on it. The punch-out bottle image can be hung from the ceiling, mimicking in real space the floating bottle on the Kombucha Web site.

"We didn't want it to compete with bottled water or tea or beer or any other product. We needed to keep it a little mysterious and unknown, from no specific place or time. Make the people have to discover it," Braithwaite says. "We like the idea of discoverability of a brand. It involves the consumer more in the process. If they don't figure it out completely, at least they will try to make it their own. It's not like Coca-Cola or some other commoditized soft drink where the product is only made interesting through millions of dollars of advertising and promotion."

The logo, which has a shape that's somewhat Arabic, contains the product's name. The engraved personality of the all-capital-letters Rosewood font makes the brand feel as though it might be old, but the shape of the stock bottle suggests that it is more contemporary. A secondary typeface on the bottle, Art Gothic, has a distinctly Asian flair. The bottle's silver cap carries a secondary identifier—KWD—that has become useful as a mark on other Kombucha-related marketing materials.

"There is a significant risk in doing what we did: People may not understand the product," Braithwaite says. "We can't spend millions on advertising, so the product has to grow through word of mouth and pleasant experience [to develop a reputation as] an exclusive product. Once people find it, they know it and tell their friends about it. And it has turned out to very giftable [in a three-bottle gift pack], which is really high praise for a product."

So far, Kombucha Wonder Drink has been a huge success. Introduced to the market only in late 2001 and initially intended for a West Coast launch, it has attracted distributors throughout the U.S. and several foreign countries. Many stores are finding it difficult to keep an adequate inventory, Stephen Lee says happily.

800.com
Identity Design

Sandstrom Design, Portland, OR

800.com is one of those smart and lucky online retailers that has so far survived the dot-com crashes. The venture-capital-funded company sells electronics such as TVs, stereos, video cameras, and more over the Web.

But 800.com's virtual status does not mean that it has little or no contact with its customers. In fact, the company prides itself on its excellent customer service. Communicating this trait was one of the company's main concerns when it went in search of a new identity to replace its rather unremarkable original mark.

"They had a swoopy, multicolored logo that had no relevance to their business or electronics. It was pretty clunky and uninspired," recalls Sandstrom Design president Rick Braithwaite. "They

needed something that fit their personality better, to show they are dedicated to customer satisfaction. In fact, the theme that their advertising agency had developed for them was 'Be happy.'"

Two other design firms had already attempted—unsuccessfully—to solve 800.com's identity crisis. One offshoot of their work was a suite of simple line drawings depicting objects, such as a television and a radio with radiating sound waves, that described different product categories. Sandstrom designer Dan Richards decided to continue working with this style of basic language.

Richards and his team came up with three designs. The first two were more traditional corporate marks, featuring bright colors, crisp graphic symbols related to electronics, and a tightly incorporated company name. The third idea soon emerged as the favorite, however. The most direct and whimsical of the three, it was a drawing of the face of a single electrical outlet with the slot for the grounding prong turned upside down to form an engaging smile.

"It was unusual and surprising as a logo," Braithwaite says. But not everyone in the audience at the presentation—mostly engineers—was convinced. "But we had gone back to their very first conversations with us and called out all of the factors they had listed as important. Then we rated each of the three concepts against the factors. The plug was clearly winning in each category."

This quantified the results for the mathematically minded engineers, and they came on board. "We just used a method that they were familiar and comfortable with," Braithwaite explains.

The designers chose to color the logo lime green for its unusual, happy feeling, and the company's name, printed below the face in hand-drawn sans serif type, mimics the art's attitude. The finished logo definitely presents a friendly face.

800.com
electronics

800.com
electronics

Greg Drew
Customer Service
Representative
President and CEO

Tel. 503-944-3612
Fax. 503-944-3691

ROBERT S. FALCONE
Senior Vice President,
Chief Financial Officer

800.com, Inc.
1516 NW Thurman
Portland, OR 97209
www.800.com

Tel. 503-944-3677
Fax. 503-944-3691

bfalcone@800.com

800.com
electronics

800.com, Inc. 1516 NW Thurman Portland, OR 97209 Tel. 503-944-3600 Fax. 503-944-3690 www.800.com

Learning Curve, the parent company behind many educational toy lines, is an expert in offering products that it calls "playtime-enrichment toys." Focus-group studies agreed, as did the specialty stores that carry the company's products.

In fact, just about everyone agreed that if there was a manufacturer that was altruistic and trustworthy enough to be recognized as a leader in developmental toys, it was Learning Curve.

Parham Santana was brought in by Learning Curve's management to create a more muscular brand for the company. The design firm felt that its client deserved the cachet of being the expert in their field, and the firm set out to proclaim it graphically.

> "We felt the most efficient and effective way to express this was a seal of approval that celebrates the child's achievements."

"We were very impressed with the care and professionalism that they put into the development of their products," explains John Parham, principal of the brand strategy and design firm. "We felt the most efficient and effective way to express this was a seal of approval that celebrates the child's achievements and stands out so moms can track the products on the shelf and go on to new products as the child grows."

Learning Curve CEO John Lee had brought an entire range of developmental toy brands, including Thomas and Friends, Lamaze, Felt Kids, Madeline, and Eden, under the umbrella of his company to cover the 0- to 12-year-old market. But making retailers and consumers aware of Learning Curve while maintaining the sub-brand integrity of its products was a challenge. Before Parham Santana began work on the project, Learning Curve International realized that it owned significant shelf presence, though its name remained relatively unknown to consumers.

The new Learning Curve identity mark is housed in what looks like a quality seal. The new identity has a celebratory feel, lauding the brand as well as the achievements of the children who play with the company's toys.

Learning Curve's original logo felt cold and seemed more appropriate for a bank or mutual fund. However, Parham Santana's designers felt it was important to keep some aspect of the old mark's ascending curve in the new mark.

Lamaze® Infant Development System®
Ambi Toys®

Learning Curve℠

The new mark was designed—in both color and shape—so it could be applied to the packaging of any of Learning Curve's sub-brands.

In some corporate applications, the mark is used alone, without the seal or the ribbon.

The design team felt that the new logo should maintain the curved motif, but they took it in a more emotional and aspirational direction.

Another challenge was a market crowded with educational toys of many brands, all making varying claims and all of varying quality. How could Learning Curve be made to stand out as the premier and most trusted company?

To distinguish Learning Curve, Parham Santana studied the competition so they could define their client's MVP, or "most valuable positioning." The design firm concluded that Learning Curve was not necessarily in the toy business, but rather in the business of "playtime enrichment." So the client and designers worked together to establish an identity that was much more emotional and in touch with the aspirations mothers have for their children.

The company's original mark was a small, curved, ascending graphic meant to visually describe the good-for-you learning toys they manufacture along the learning curve for infants and children up to age twelve. While accurate, the mark did not communicate the fun and emotional appeal of the brand's offerings.

"It looked institutional, like a bank logo or a mutual fund mark," says Parham. "It told one story, that of a learning curve serviced by toy brands, but the larger story was more intriguing: Learning Curve is actually a group of do-good professionals who develop and test toys so that they are the best they can be. They produce some very fun and creative products."

The design team felt that the new logo should maintain the curved motif, but they took it in a more emotional and aspirational direction: The curve is now the tail of a shooting star, which playfully dots the i in *Learning*. For the type, the designers replaced the cold sans serif of the original design with a warmer, more human serif face. The serif typeface is also evocative of education, as most children's books and school materials use a serif type.

"The new mark is more celebratory," says principal Maruchi Santana, "because when you have a child growing through developmental toys, you are celebrating every achievement. The stars give that feeling of celebration."

While the shooting-star mark is used together with the company name on stationery and select corporate materials, the designers took the graphic one step further for use on packaging, promotional materials, signage, and other consumer communications. The firm placed the identity inside a yellow seal, essentially a seal of approval. The yellow is sunny and happy, and Learning Curve's logo is in red, the most recognizable color on store shelves. Together, the colors feel warm and rich. The color combination also coordinates well with the many designs and colors of the packaging to which the seal is applied. It also provides a shape and background that can be combined with the identity of any of the company's sub-brands.

Time to spend with friends.

New!
Battery-
Powered
Thomas!

What makes The Thomas and Friends™ Wooden Railway System #1 in America? Exceptional quality, classic products, and most especially train characters that Clickity-Clack their way into kids' hearts.

THE THOMAS WOODEN RAILWAY SYSTEM IS:
- Wooden Train play - 2 to 3 and up
- A system of over 140 age-graded products
- Exceptionally well-made - handcrafted from New England Hard Maple
- Elaborately detailed with colorful Island of Sodor graphics
- Unconditionally guaranteed - for life!

PLAYTIME ENRICHMENT:
Problem solving, motor skills, math skills, social skills, construction, imaginative play

In these trade communication slicks, the Learning Curve seal is used without the ribbon. In the example at the top, the seal shape is used as a burst to call out a new feature instead of advertising Learning Curve's name.

"We did meet with some resistance on the seal internally," says Parham of the client's reaction to the design. "Some people felt [it would look] like [they] were awarding [themselves] this honor. But we told them, 'If you don't do it, who will?' And in addition, it won't be long until someone else will make the claim," says Parham. "Learning Curve saw the credibility this could gain for the company immediately, and focus testing bore this out."

The consumers in those focus groups immediately appreciated the meaning of the seal and loved the aspirational implication of the stars. To them, the seal meant "approval" or "officially good," without making any overt claims. Placed on the front of packages, the seal identifies the main brand, Learning Curve, but cordially allows the sub-brand to introduce itself to the shopper. A consumer can find the sub-brand of toy they're used to searching for, but can still feel secure that when the seal is visible, they are shopping along the learning curve.

The new identity seems to be working on all fronts. The client is pleased: Polly MacIsaac, vice president of marketing for Learning Curve International, feels that her company now has a smart and proprietary positioning, as well as a clear, clean branding architecture. Investors and the trade community are embracing the idea that the company is selling more than just toys. And kids, of course, are continuing to have fun and develop with Learning Curve products.

StatCard
Identity Design

Parham Santana, New York, NY

StatCard is a trading card with a difference: It depicts a character or athlete like a traditional trading card, but StatCards are "smart" trading cards: They contain a computer chip. With one of these cards and a special reader unit attached to your computer, you can play animated games online with other StatCard owners. As your character wins or loses in battles or challenges, the card accrues or lessens in value.

That's what makes StatCard so interesting, explains John Parham of Parham Santana, the New York branding agency that developed the positioning, identity, packaging, and rollout materials for the innovative product.

"[The value of] regular trading cards is relatively stable. With a StatCard, your cards can increase in value [from one hour to the next]," he says. "You can display that value online or put it in your reader. StatCard takes the play pattern of trading cards and takes it to the next level."

Because this was a new product—and a new technology with a new play pattern—the designers had to be certain that the identity communicates as quickly as possible what the product is and does. Their client didn't have endless marketing dollars or years to explain an abstract mark like the Nike swoosh, for example. The identity had to instantly communicate that this is new, this is a trading card, and this is a card that you plug into something."

The Parham Santana designers first experimented with designs that centered around the embedded chip, but then decided that that wasn't really what was unique about the cards since many phone cards, credit cards, and debit cards carry smart chips, too. So they circled back to the product tag line the firm had created: "Load 'em. Play 'em. Trade 'em." Then their experiments became

more proactive and driven by the action of loading the card into a reader and starting an interactive experience.

The fairly complex process was reduced to two simple shapes representing a trading card and a point of entry. The final design showed the trading card entering a vortex, which suggested the endless possibilities of the interactive experience.

"This had to be unisex and proactive," says principal Maruchi Santana. The designers presented the mark to the client in the context of many different types of packaging, since the product has the potential to be used with everything from action games to Barbie adventures. "A product this versatile has to be shown to work with many different brands," she adds.

The product line was launched at the Toys "R" Us flagship store in New York's Times Square and was an immediate hit with consumers. Based on its success there, it is now being rolled out to Toys "R" Us stores nationwide.

The client is pleased with the identity, especially given the complexity of launching not only a new brand, but a new product, technology, and play pattern as well. "We had to make the retailer feel comfortable with our ability to communicate this concept to consumers. We had to make the consumer feel like this was a product they understood and wanted to buy," explains Maggie Trujillo, chief operating officer of StatCard. "In addition to these short-term goals, we need the marketplace to be familiar with StatCard as a brand in order to pave the way for the future, when many more products will be using smart card technology for entertainment purposes. Parham Santana's work has been critical to our success to date."

collections and sketches

Ⓓ = Design Firm
Ⓒ = Client

LOGO SEARCH

Keywords **Initials**

Type: ○ Symbol ○ Typographic ○ Combo ● All

1

2

3

4

5

 1

 2

 3

 4

 5

	Ⓐ	**Ⓑ**	**Ⓒ**	**Ⓓ**

①

②

③

④

⑤

1A Ⓓ Howalt Design Studio, Inc. Ⓒ Blackstone 1B Ⓓ Howalt Design Studio, Inc. Ⓒ Blackstone 1C Ⓓ Planet Propaganda Ⓒ Sherpa 1D Ⓓ Design and Image Ⓒ Blueline 2A Ⓓ Stone & Ward Ⓒ Marketplace Grill
2B Ⓓ Chermayeff & Geismar, Inc. Ⓒ Beaunit 2C Ⓓ Hornall Anderson Ⓒ Blue Nile 2D Ⓓ Hutchinson Associates, Inc. Ⓒ BRX 3A Ⓓ Trickett & Webb European Ⓒ Science Foundation
3B Ⓓ Richards Brock Miller Mitchell & Associates Ⓒ Circuits 3C Ⓓ Jon Flaming Design Ⓒ Creative Printing 3D Ⓓ CRE8 Communications, Inc. Ⓒ The Certus Group 4A Ⓓ Sayles Graphic Design, Inc. Ⓒ Christopher's Restaurant
4B Ⓓ Pat Taylor Inc. Ⓒ Commons Corporate Center 4C Ⓓ Gardner Design Ⓒ Christy Peters 4D Ⓓ Prejean LoBue Ⓒ Cnet Telecommunications 5A Ⓓ Sabingrafik, Inc. Ⓒ Current Communications
5B Ⓓ Chermayeff & Geismar, Inc. Ⓒ Centro de Convenciones de Cartagena 5C Ⓓ Braue; Branding & Corporate Design Ⓒ Sony – Columbia Records 5D Ⓓ Design and Image Ⓒ CLC Associates

 1

 2

 3

 4

 5

1A Ⓓ Webster Design Associates Inc. Ⓒ Carlson West Povondra Architects 1B Ⓓ SPATCHURST Ⓒ Digital Art Directory 1C Ⓓ Richards Brock Miller Mitchell & Associates Ⓒ Dallas Symphony Orchestra
1D Ⓓ Chermayeff & Geismar, Inc. Ⓒ Demir Dokum 2A Ⓓ Chermayeff & Geismar, Inc. Ⓒ D Day National Museum 2B Ⓓ James Lienhart Design Ⓒ Dunbar Builders 2C Ⓓ Design Machine Ⓒ Design Machine
2D Ⓓ Beth Singer Design Ⓒ Democratic National Committee 3A Ⓑ Dotzero Design Ⓒ Digital Planet 3B Ⓓ Planet Propaganda Ⓒ EuroArte 3C Ⓓ Rickabaugh Graphics Ⓒ Beckett Paper
3D Ⓓ Chermayeff & Geismar, Inc. Ⓒ Engraved Stationery Manufacturers Association 4A Ⓓ Hornall Anderson Ⓒ Elseware Corporation 4B Ⓓ Pat Taylor Inc. Ⓒ Frank Evans Art Supplies 4C Ⓓ Grapefruit Design Ⓒ Media Engine
4D Ⓓ Bumba Design Ⓒ Estes Music Management and Entertainment 5A Ⓓ Miriello Grafico, Inc. Ⓒ Encorrot Sportswear 5B Ⓓ Sanna Design Group, Inc. Ⓒ Orange E - Graphic 5C Ⓓ Pat Taylor Inc. Ⓒ Everly Elevator Service
5D Ⓓ Grapefruit Design Ⓒ eResources, Inc.

1

2

3

4

5 GSD&M

1A Ⓓ Chermayeff & Geismar, Inc. Ⓒ Embassy Communications 1B Ⓓ Prejean LoBue Ⓒ EFCO Corporation 1C Ⓓ Wages Design Ⓒ eHatchery 1D Ⓓ GTA - Gregory Thomas Associates Ⓒ Condo Exchange

2A Ⓓ Hornall Anderson Ⓒ Microsoft Corporation 2B Ⓓ Cato Purnell Partners Ⓒ Eden Quarter 2C Ⓓ John Evans Design Ⓒ Squires and Co. 2D Ⓓ Sandstrom Design Ⓒ FSU 3A Ⓓ Simon & Goetz Design Ⓒ Fx Chmidt Spiele

3B Ⓓ Gardner Design Ⓒ Lazy G Ranch 3C Ⓓ Kontrapunkt Ⓒ The Geological Survey of Denmark and Greenland 3D Ⓓ Liska + Associates Communication Design Ⓒ Geldermann 4A Ⓓ Simon & Goetz Design Ⓒ Grow

4B Ⓓ Grapefruit Design Ⓒ Boston Media Corporation 4C Ⓓ Liska + Associates Communication Design Ⓒ GCG Financial 4D Ⓓ BrandEquity Ⓒ General Cinema Corporation

5A Ⓓ Chermayeff & Geismar, Inc. Ⓒ GF Business Equipment 5B Ⓓ Graves Fowler Associates Ⓒ Graves Fowler Associates 5C Ⓓ Design and Image Ⓒ Gorsuch Kirgis 5D Ⓓ Sibley Peteet Design Ⓒ GSD&M

74

1A Ⓓ Chermayeff & Geismar, Inc. Ⓖ Halaby International 1B Ⓓ Chermayeff & Geismar, Inc. Ⓖ Heritage Trails 1C Ⓓ Kellum McClain Inc. Ⓖ Hybrid Recordings 1D Ⓓ Richards Brock Miller Mitchell & Associates Ⓖ Hope Cottage

2A Ⓓ John Silver Ⓖ Hairbrain Films 2B Ⓓ Jon Flaming Design Ⓖ Hannah Flaming 2C Ⓓ Sibley Peteet Design Ⓖ Hyde Park Gym 2D Ⓓ Hornall Anderson Ⓖ Harris Group 3A Ⓓ Liska + Associates Communication Design Ⓖ Heltzer, Inc.

3B Ⓓ Hornall Anderson Ⓖ Hardware.com 3C Ⓓ Wages Design Ⓖ Hardin Construction 3D Ⓓ Balance Ⓖ Humaneered 4A Ⓓ Planet Propaganda Ⓖ The Hiebing Group 4B Ⓓ MB Design Ⓖ Hotel Bellwether

4C Ⓓ Gardner Design Ⓖ Hite Fanning Honeyman 4D Ⓓ Design Machine Ⓖ Hi beam 5A Ⓓ BBK Studio Ⓖ Herman Miller 5B Ⓓ Design and Image Ⓖ People I Know 5C Ⓓ Roman Design Ⓖ Fortress Technologies, Inc.

5D Ⓓ James Lienhart Design Ⓖ International Typetronics

❶

❷

❸

❹

❺

1A Ⓓ Design Machine Ⓒ L2 1B Ⓓ MB Design Ⓒ James Alan Salon 1C Ⓓ Chermayeff & Geismar, Inc. Ⓒ Krystal 1D Ⓓ Gardner Design Ⓒ Kimball Insurance 2A Ⓓ Chase Design Group Ⓒ Kemper Snowboards
2B Ⓓ Saturn Flyer Ⓒ KRYPTOSIMA 2C Ⓓ James Lienhart Design Ⓒ Kellogg School of Business 2D Ⓓ Chermayeff & Geismar, Inc. Ⓒ Knapp Shoes 3A Ⓓ Chermayeff & Geismar, Inc. Ⓒ Katonah Museum of Art
3B Ⓓ Prejean LoBue Ⓒ Kirk Worden Photography 3C Ⓓ Gardner Design Ⓒ Integrated Interiors 3D Ⓓ Angryporcupine Ⓒ K&M Productions 4A Ⓓ Modern Dog Communications Ⓒ K2 Snowboards
4B Ⓓ Modern Dog Communications Ⓒ K2 Snowboards 4C Ⓓ Modern Dog Communications Ⓒ K2 Snowboards 4D Ⓓ Modern Dog Communications Ⓒ K2 Snowboards
5A Ⓓ Liska + Associates Communication Design Ⓒ Loret Carbone 5B Ⓓ Kiku Obata & Company Ⓒ LoftWorks, LLC. 5C Ⓓ MB Design Ⓒ Lisa Ershig Interiors 5D Ⓓ Pat Taylor Inc. Ⓒ Magna-Check Corporation

76

1

MARSON

m
&a

M&A COLLECTIONS

mark
bergsma
G A L L E R Y

2

3

maak1

4

net trekker

NORTHWESTERN NASAL + SINUS

5

1A Ⓓ Pogon Ⓒ Only 1B Ⓓ Rickabaugh Graphics Ⓒ The Ohio State University 1C Ⓓ Hornall Anderson Ⓒ Space Needle 1D Ⓓ Chermayeff & Geismar, Inc. Ⓒ Owens-Illinois 2A Ⓓ Chermayeff & Geismar, Inc. Ⓒ Georgia O'Keeffe Museum

2B Ⓓ Tim Frame Ⓒ Brainstorm Design 2C Ⓓ Howalt Design Studio, Inc. Ⓒ OP 2D Ⓓ Elixir Design Ⓒ Perspecta, Inc. 3A Ⓓ Planet Propaganda Ⓒ Planet Propaganda 3B Ⓓ Gardner Design Ⓒ PrintMaster Printing

3C Ⓓ Planet Propaganda Ⓒ Planet Design Company 3D Ⓓ Wages Design Ⓒ Pfrimmer 4A Ⓓ Sibley Peteet Design Ⓒ Paramount Theater 4B Ⓓ Howalt Design Studio, Inc. Ⓒ Palm pda 4C Ⓓ Simon & Goetz Design Ⓒ Sachs

4D Ⓓ Art Chantry Ⓒ Quester 5A Ⓓ Balance Ⓒ Quotes & Notes 5B Ⓓ Webster Design Associates Inc. Ⓒ Quality Refrigeration 5C Ⓓ Wages Design Ⓒ Fleming H Revell Publishing

5D Ⓓ Eisenberg and Associates Ⓒ Reid Park Zoo, Tucson

1

2

3

4

5

❶

❷

❸

❹

❺

 ①

 ②

 ③

 ④

 ⑤

1A Ⓓ Braue; Branding & Corporate Design Ⓒ Braue 1B Ⓓ Gardner Design Ⓒ VizWorx 1C Ⓓ Richards Brock Miller Mitchell & Associates Ⓒ Hillwood 1D Ⓓ Simon & Goetz Design Ⓒ ZDF 2A Ⓓ Angryporcupine Ⓒ QV Design
2B Ⓓ Mires Ⓒ Verde Communications 2C Ⓓ John Silver Ⓒ Vaughn Williams 2D Ⓓ Cato Purnell Partners Ⓒ Bank West 3A Ⓓ Hornall Anderson Ⓒ Watson Furniture Company 3B Ⓓ Howalt Design Studio, Inc. Ⓒ Winternet
3C Ⓓ Monigle Associates Inc. Ⓒ Winterthur Museum, Garden, and Library 3D Ⓓ Hornall Anderson Ⓒ Widmer Brothers Brewery 4A Ⓓ Blue Beetle Design Ⓒ Woodsmith 4B Ⓓ Howalt Design Studio, Inc. Ⓒ Work, Inc.
4C Ⓓ Evenson Design Group Ⓒ Waldorf Crawford 4D Ⓓ CRE8 Communications, Inc. Ⓒ Western Recreational Vehicles, Inc. 5A Ⓓ Henderson Tyner Art Co. Ⓒ Winston-Salem Symphony
5B Ⓓ Design and Image Ⓒ Wewatta Transfer 5C Ⓓ Chase Design Group Ⓒ Tony Williams 5D Ⓓ Chermayeff & Geismar, Inc. Ⓒ Waterside 81

Ⓐ

Ⓑ

Ⓒ

Ⓓ

①

②

③

④

⑤

1A Ⓓ DK Design Ⓒ Six Flags Magic Mountain 1B Ⓓ Sterling Group Ⓒ Exenet 1C Ⓓ After Hours Creative Ⓒ ENX 1D Ⓓ Simon & Goetz Design Ⓒ Yarell GMBH 2A Ⓓ Sibley Peteet Design Ⓒ Yancy's Bar

2B Ⓓ Hecht Design Ⓒ Zipcar 2C Ⓓ Bright Strategic Design Ⓒ NetZero, Inc. 2D Ⓓ Miriello Grafico, Inc. Ⓒ Hot Z Golf 3A Ⓓ Hecht Design Ⓒ Zmed 3B Ⓓ Liska + Associates Communication Design Ⓒ Elizabeth Zeschin Photography

3C Ⓓ AdamsMorioka, Inc. Ⓒ VH1 3D Ⓓ After Hours Creative Ⓒ Just 1 4A Ⓓ Hornall Anderson Ⓒ Cellular One 4B Ⓓ AdamsMorioka, Inc. Ⓒ AIGA 4C Ⓓ Chermayeff & Geismar, Inc. Ⓒ WGBH Educational Foundation

4D Ⓓ Howalt Design Studio, Inc. Ⓒ Radio in the Nude 5A Ⓓ Howalt Design Studio, Inc. Ⓒ East3 5B Ⓓ Cato Purnell Partners Ⓒ AGIdeas 5C Ⓓ Simon & Goetz Design Ⓒ Sachs 5D Ⓓ MB Design Ⓒ Haskell Corporation

82

	A	**B**	**C**	**D**	
				1	
				2	
				3	
				4	
				5	

Scone on the Range
Product Identity and Packaging

Gardner Design, Wichita, KS

What's a designer to do when a brand-new client insists on using log-style type as part of her new identity? If you were on the design team at Gardner Design working on the Scone on the Range brand, you cringed a little, then listened a lot.

Marilyn Naron had already had an unsuccessful experience working with another design firm when she came to Wichita-based Gardner Design seeking packaging and an identity for her line of frozen scones. With the Chisholm Trail literally bordering her yard in Lawrence, Kansas, and a wholesome, to-be-baked product for sale, she had visions of the prairie in mind, mixed with the public-service flavor of the Depression-era Works Progress Administration (WPA) and a hint of the inherent Britishness of scones. Perhaps, Naron suggested, the logo could show a prairie woman standing at a stove, surrounded by the product name set in log type.

Art directors Chris Parks and Brian Miller, together with principal Bill Gardner, concentrated on finding a way to depict Naron's vision. "In the beginning, we thought it was hokey. But then we saw if we could just stick with this for a while, it might just work," says Parks.

They decided to use the log type to evoke the image of pioneers, but to contemporize it and the elements that would surround it. After researching log typefaces, they discovered that most were too detailed. Then the designers had a stroke of luck: On a department-store box from the 1940s, they found a simpler face, which they used as a point of departure for their own work.

The product was to be sold in grocery and health food stores, so it needed to look simultaneously corporate and homey. They decided to make the packaging more corporate and keep the logo homey.

For the logo, the designers considered the type of crude graphics one might see at a roadside produce stand. They set the name

in a log typeface, but it's a face with some finesse. Centered in the design is a graphical representation of Naron stirring dough in a bowl, portraying the WPA heroine Rosie the Riveter had she been standing strong on the plains. Other subtle touches, such as setting *on the* in a scroll and gray curlicues in the background add classic touches.

When evaluating colors, the designers noted that most of the competing brands on the market used very dark colors, predominately red and black.

"It was all very classic," says Gardner. "So Chris really paid attention to making the Scone's packaging different, but just as rich." The swirling, creamy tans and browns used for the company's boxes are certainly rich enough to give the product strong shelf appeal, but they also allow the box to sit comfortably in health or natural food stores, where many products are in brown or kraft paper packaging.

D = Design Firm
C = Client

LOGO SEARCH

Keywords | **Typography**

Type: ○ Symbol ○ Typographic ○ Combo ● All

Filmcore

oppor2unity **1**

estyle.com
kidstyle.com
babystyle.com

hi?fi
TUESDAYS

Bike (LIFT)™

How tight? **2**

workplace
ANSWERS

PaineWebber

National Symphony

shaw | contract group **3**

moncloa

[GILDAMARX]

i scribe™

·scentsations· **4**

CIVITAS

ANGEL

CROWN
Vantage

MATTEO **5**

1C **D** Sandstrom Design **C** FilmCore 1D **D** Kellum McClain Inc. **C** Greco Ethridge, Inc. 2A **D** Chase Design Group **C** estyle.com 2B **D** Proart Graphics/Gabriel Kalach **C** Joy Night Club 2C **D** Sandstrom Design **C** Bike Lift
2D **D** Pat Taylor Inc. **C** Typographers International Association 3A **D** Sackett Design **C** Workplace Answers 3B **D** Chermayeff & Geismar, Inc. **C** PaineWebber 3C **D** Chermayeff & Geismar, Inc. **C** National Symphony Orchestra
3D **D** Wages Design **C** Shaw Industries 4A **D** Artimana **C** Moncloa 4B **D** Chase Design Group **C** Gilda Marx 4C **D** Addis **C** Iscribe 4D **D** MB Design **C** Scentsations 5A **D** Essex Two Inc. **C** CIVITAS
5B **D** Chase Design Group **C** The WB 5C **D** Monigle Associates Inc. **C** Crown Vantage 5D **D** Chase Design **C** Group Matteo

85

	A	**B**	**C**	**D**
1	MARK LANEGAN WHISKEY FOR THE HOLY GHOST	BARNEYS NEWYORK	[UNDER WIRE)	COLTON GROOME Company
2	PLAZA FRONTENAC	SIX DEGREES	MORGAN STANLEY	RENÉ LEZARD
3	FOSTER HART LAWYERS	COLUMBIA WINERY	M&J WILKOW	AQUAVEDIC
4	ORIENT EXPRESS	GEMOPTICS	LYONTEX	BRIGHTON POINTE
5	RADAR INVESTMENTS	CHAMPS	MONSANTO Food · Health · Hope™	W●RLD POLICY

	A	**B**	**C**	**D**
1	tastylick	garageband.com	Children's HOSPITAL · ST. LOUIS	Think Outside
2	Litton	Mobil	Hansol	FEED
3	Assurant Group	TypeCon2002	Itron	aftermedia
4	‹caljisma›	Chemistry Place C.P	gothmann	whodoo
5	ibid.	blur Convergent Marketing	Bravo	euiu

1A **D** Orange 32 **C** Tastylick Studios 1B **D** Plumbline Studios **C** GarageBand.com 1C **D** Rodgers Townsend **C** Children's Hospital 1D **D** Mires **C** Think Outside 2A **D** GTA - Gregory Thomas Associates **C** Litton Industries
2B **D** Chermayeff & Geismar, Inc. **C** Mobil Corporation 2C **D** Chermayeff & Geismar, Inc. **C** Hansol Paper 2D **D** Chermayeff & Geismar, Inc. **C** Feed Magazine 3A **D** Wages Design **C** Assurant Group
3B **D** Brian Sooy & Co. **C** Society of Typographic Aficionados 3C **D** Monigle Associates Inc. **C** Itron 3D **D** Plumbline Studios **C** AfterMedia 4A **D** Angryporcupine **C** Callisma 4B **D** Plumbline Studios **C** Addison Wesley Longman
4C **D** Braue; Branding & Corporate Design **C** Gothmann Optik 4D **D** Chase Design Group **C** Whodoo 5A **D** Chermayeff & Geismar, Inc. **C** Ibid Stock Photo 5B **D** Laura Manthey Design **C** Blur Convergent Marketing
5C **D** Kellum McClain Inc. **C** Bravo Network 5D **D** Artimana **C** UOC

	Ⓐ	**Ⓑ**	**Ⓒ**	**Ⓓ**
❶	objx	ripe	Quris™	karma!
❷	dawson CONSTRUCTION INC	The Museum of Modern Art	flyingco. company rewards for business travel	virgin atlantic
❸	⊁ⱶ Helion	PRECISION, INC.	URBANAGENTS	DOVEBID Business Auctions Worldwide
❹	DiME.	SEKAS	BEST	CUFF
❺	I·N·F·I·N·E·E·R	VERIO	S∘P∘A∘C∘E	PICNÍQUE

1A Ⓓ Liska + Associates Communication Design Ⓒ Colin Ross Design 1B Ⓓ BBK Studio Ⓒ Ripe 1C Ⓓ Design and Image Ⓒ Quris 1D Ⓓ Luce Beaulieu Ⓒ Good Life Crew/Club Living 2A Ⓓ MB Design Ⓒ Dawson Construction
2B Ⓓ Chermayeff & Geismar, Inc. Ⓒ The Museum of Modern Art 2C Ⓓ Start Design Ltd. Ⓒ Virgin Atlantic Airways Ltd. 2D Ⓓ Start Design Ltd. Ⓒ Virgin Atlantic Airways Ltd. 3A Ⓓ Addis Ⓒ Helion
3B Ⓓ Chermayeff & Geismar, Inc. Ⓒ Precision, Inc. 3C Ⓓ 2b1a Ⓒ Urban Agents 3D Ⓓ Addis Ⓒ Dovebid 4A Ⓓ Chermayeff & Geismar, Inc. Ⓒ Dime Saving Bank of New York 4B Ⓓ Pogon Ⓒ Mapa, Montenegro
4C Ⓓ Chermayeff & Geismar, Inc. Ⓒ Best Products 4D Ⓓ Hoyne Design Ⓒ Cuff 5A Ⓓ Chermayeff & Geismar, Inc. Ⓒ Infineer 5B Ⓓ Cronan Group Ⓒ Picnique 5C Ⓓ Hornall Anderson Ⓒ Space Needle
5D Ⓓ Chermayeff & Geismar, Inc. Ⓒ Picnique Frozen Yogurt

1

2

3

4

5

1A ▶ Willoughby Design Group ▣ Robyn Nichols 1B ▶ Addis ▣ Aura Cacia 1C ▶ Kiku Obata & Company ▣ The Pageant 1D ▶ Beth Singer Design ▣ Hillel: The Foundation for Jewish Campus Life

2A ▶ BrandEquity ▣ Haworth 2B ▶ Essex Two Inc. ▣ Bell+Howell 2C ▶ Lexicon Graphix, Inc. ▣ Jet Black 2D ▶ Trickett & Webb ▣ Reuter Brooks Couriers 3A ▶ Richards Brock Miller Mitchell & Associates ▣ Cityplace

3B ▶ Hutchinson Associates, Inc. ▣ Ranger Wireless Solutions 3C ▶ Hornall Anderson ▣ Active Voice 3D ▶ Proart Graphics/Gabriel Kalach ▣ G2 Team Sales 4A ▶ Hornall Anderson ▣ Imind Corporation

4B ▶ Hornall Anderson ▣ General Magic 4C ▶ Hornall Anderson ▣ Print Northwest 4D ▶ Trickett & Webb ▣ RIBA 5A ▶ Hornall Anderson ▣ Novell, Inc. 5B ▶ Wages Design ▣ Rememberit.com

5C ▶ Hornall Anderson ▣ Conversá 5D ▶ Hecht Design ▣ Conect

LOGO SEARCH

Ⓓ = Design Firm
Ⓒ = Client

Keywords | **Enclosures**

Type: ○ Symbol ○ Typographic ○ Combo ● All

①

②

③

④

⑤

1A Ⓓ Lieber Cooper Associates Ⓖ KIVA - Chicago, Illinois 1B Ⓓ Chermayeff & Geismar, Inc. Ⓖ Pilobolus Dance Company 1C Ⓓ Hornall Anderson Ⓖ Onkyo Corporation 1D Ⓓ Richards Brock Miller Mitchell & Associates Ⓖ Know AIDS

2A Ⓓ Richards Brock Miller Mitchell & Associates Ⓖ Lomas 2B Ⓓ Art Chantry Ⓖ Impala Square Jungle 2C Ⓓ Chermayeff & Geismar, Inc. Ⓖ Liz Claiborne 2D Ⓓ Liska + Associates Communication Design Ⓖ First Aid

3A Ⓓ Art Chantry Ⓖ Free South Africa 3B Ⓓ CRE8 Communications, Inc. Ⓖ Tom Kelby Copywriter 3C Ⓓ Sayles Graphic Design, Inc. Ⓖ Timbuktuu 3D Ⓓ Cato Purnell Partners Ⓖ Raffles Hotel 4A Ⓓ Device Ⓖ Club Spirit

4B Ⓓ Howalt Design Studio, Inc. Ⓖ Sears 4C Ⓓ Dotzero Design Ⓖ Wichita Blues Society 4D Ⓓ Dotzero Design Ⓖ Louisiana Pacific 5A Ⓓ CRE8 Communications, Inc. Ⓖ The Sign Producers

5B Ⓓ BrandEquity Ⓖ Levi Strauss & Co., Inc. 5C Ⓓ Balance Central Ⓖ Design District, Austin 5D Ⓓ AdamsMorioka, Inc. Ⓖ Slamdance Film Festival

 1

 2

 3

 4

 5

1A Ⓓ Art Chantry Ⓒ The Reunion Series 1B Ⓓ Art Chantry Ⓒ The Cowslingers 1C Ⓓ Braue; Branding & Corporate Design Ⓒ Hans Fiedler Soehne GmbH 1D Ⓓ Sandstrom Design Ⓒ Radioland

2A Ⓓ Mojo Unlimited, LLC Ⓒ urbanStyle.net 2B Ⓓ Willoughby Design Group Ⓒ G. Diebolts 2C Ⓓ Chase Design Group Ⓒ Relo Pro, Inc. 2D Ⓓ Bird Design Ⓒ In Demand 3A Ⓓ Jon Flaming Design Ⓒ Neiman Marcus

3B Ⓓ Orange 32 Ⓒ DJ Skribble 3C Ⓓ AdamsMorioka, Inc. Ⓒ Catharine Fishel 3D Ⓓ Mires Ⓒ Las Vegas Chamber of Commerce 4A Ⓓ Dennis Purcell Design Ⓒ Sony Entertainment 4B Ⓓ Tim Frame Ⓒ California Design

4C Ⓓ Chase Design Group Ⓒ Kama Sutra 4D Ⓓ Willoughby Design Group Ⓒ Hallmark Flowers 5A Ⓓ Sandstrom Design Ⓒ Levi Strauss & Co., Inc. 5B Ⓓ Jon Flaming Design Ⓒ Ken Knight

5C Ⓓ Tim Frame Ⓒ Tim Frame Design 5D Ⓓ AdamsMorioka, Inc. Ⓒ Nickelodeon

ProBeauty
Corporate Identity

Braue; Branding and Corporate Design, Bremerhaven, Germany

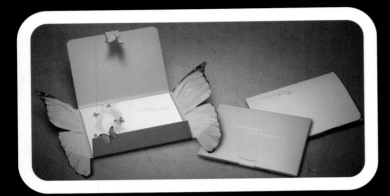

The metamorphosis from caterpillar to butterfly: That's the metaphor at the center of the ProBeauty identity created by Braue of Bremerhaven, Germany. It's a common concept, but Braue designers used production values and color to push the idea past the commonplace.

A start-up company founded by thirteen doctors and specialists, ProBeauty's staff perform cosmetic surgery and administer beauty and wellness treatments. Its typical customer is an average person who wants to get rid of a pound here or there, have a tattoo removed, or have a face-lift.

But even though the company provides surgical services, its owners wanted to de-emphasize that. Instead, they wanted to give the emotional aspects of the business more weight. Surgery feels cold and clinical to consumers, but wellness and beauty treatments definitely feel warmer.

Color was at the center of making this combination of disparate elements succeed. After conducting extensive research on the subject, art director Marcel Robbers knew which direction they had to go in.

"When you want to suggest something surgical, green implies medicine and competence," he explains. "Orange implies wellness and health. So we weighted the entire program toward the warm tones—it's much more emotional." Green typically is a cool color, so the designers switched to a warmer light green. "The combination of the light green and orange was unique," Robbers adds.

Then a butterfly entered the scene. "It is the ideal example of a living brand," Robbers says.

In designs advertising the company's services, a butterfly is depicted on the part of the human body that the subject being discussed involves. For instance, when tattoo removal is explained, the butterfly appears on a photo of an upper arm.

The most dramatic manifestation of the butterfly in print is in a "winged" folder design. Meant to hold handouts, estimates, brochures, proposals, and anything else the company might mail or distribute, large butterfly wings unfurl when the folder is opened. The folder is sized so it can be easily and discreetly tucked into a handbag.

"The company's philosophy, translated loosely from German, is, 'We unfold your beauty,'" Robbers explains. "Showing the butterfly wings coming into their full beauty put the living brand into action."

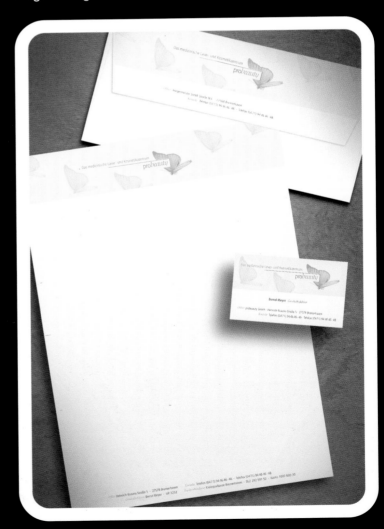

LOGO SEARCH

Keywords | Display Type |

Type: ○ Symbol ○ Typographic ○ Combo ● All

	A	B	C	D
1				
2				
3				
4	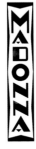			
5				

	A	B	C	D	
					1
	FLASH	the Joker's Wild!	THE JERKS	Xtreme	**2**
					3
	Crown royals	Juliet Prowse is MAME			
					4
		EXPO '97	Th + INK	eye d?s	
	sky City				**5**
		Say it	XOW!	YAK CENTRAL	

1

Ⓓ = Design Firm
Ⓒ = Client

LOGO SEARCH

Keywords | **Calligraphy**

Type: ◯ Symbol ◯ Typographic ◯ Combo ⦿ All

2

3

4

tattoo Teardrop

Dragonheart

5

Prince

	A	B	C	D	
1					1
2					2
3					3
4					4
5					5

	A	**B**	**C**	**D**
1	*Valentinoise*	*The Galaxy Trio*	*Troubled Souls*	*Muse Air*
2	*Duhart Creek*	*The Refinery*	*Steven's Brew*	*Kultūr* MINISTERIET
3	*Laser Jet*	The **Barcelona**	PORTFOLIO	blue chip c a f e
4	*Voltaire*	M.alanis [studio]	NEWBAIT	ALTA
5	**Shiner**	Genki SPA O₂ BAR	FEAR NOT	THE SUNRISE LEGEND LIVES

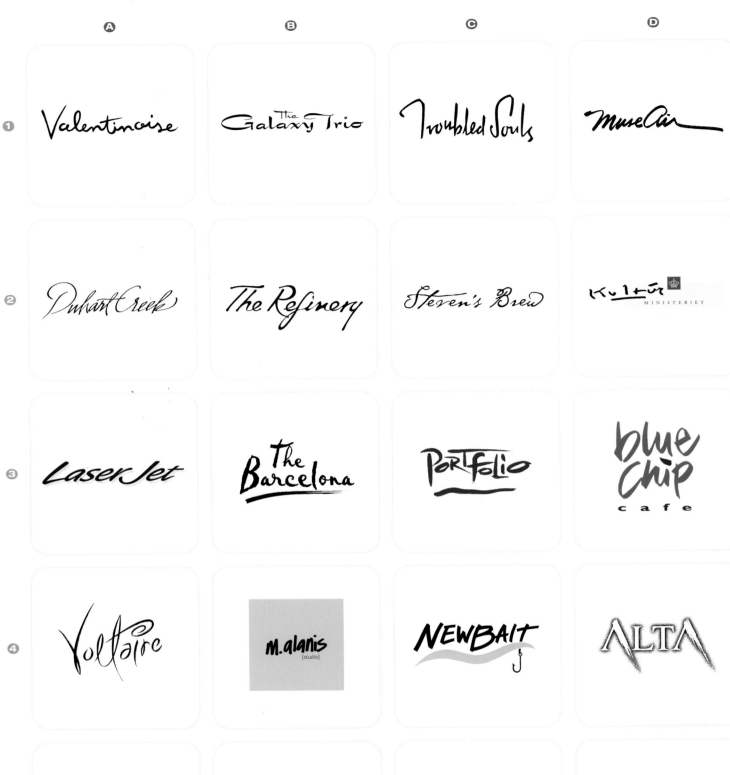

A	B	C	D	
santana	Ten Inch Men	GOLLNIK	Spirit	**1**
HeR	GELINAS	THREE	PETRA	**2**
CANDIES BIG ISLAND	HUDSON CLUB	SPARE TIME INCORPORATED	TROCADERO	**3**
Ruby	DESIRE	Beautiful Twisted	Kinnett	**4**
ECCLESTON SQUARE	VINIFERA IMPORTS	PINA TOCADOS Y COMPLEMENTOS	Teatro ZinZanni	**5**

Informative.com
Multi-Logo Identity

Felixsockwell.com, New York, NY

Felix Sockwell keeps plenty of killed work on his Web site for a very good reason: He eventually sells most of it.

"If there is a good idea in it and it hasn't been used publicly, it goes onto the site," says the former design director of Ogilvy & Mather who's now a successful solo designer and illustrator in New York City.

An assignment for Informative.com, a business-to-business information portal, is a recent success story. To create the Web site's new identity, Sockwell adapted two images from previous assignments and resurrected a killed magazine assignment.

Sockwell's involvement began when the art director of the agency handling a logo project for Informative.com spotted an illustration about health care on the Web that the artist had done for *Time* magazine, but had been rejected. The elegant, simple drawing that shows two people embracing or supporting each other was a perfect message for Informative's Web site, at which businesspeople can help themselves and others. The image would represent communication on the site.

But that was just the beginning of the job. Informative.com's organizers wanted a multi-logo identity, one in which logos could be swapped as needed for different applications.

The second and third logos were adapted from images Sockwell had done for Parsons School of Design posters several years earlier. Both of these images—one a pair of profiles joined by a palette to represent creativity or aesthetic and the other a

computer to represent digital communications—were greatly simplified from their source images.

Although the client for this project is using the artist's unique line style as a unifying element, Sockwell is not necessarily excited when potential clients call him asking for "something linear."

"You have to put something new into every job, no matter what your style is," he says. "The best thing to do is to look around at what is being done and then do something different. I try not to do anything that looks like an AT&T logo or Nike swoosh. I never have done anything like those. Trends don't last. I stick with content, and try to do something new with that."

Once a logo is ready to be presented, Sockwell considers it crucial to show the client what he calls the logo's "arms and legs." He'll spend extra time and money demonstrating different applications for the mark: What it could be applied to, how it could be produced, what it would look like embossed, in various colors, and animated for the Web.

Sockwell advises that it's important for designers to keep in mind that they, the logo's creators, likely will not be at every presentation of the proposed mark. "So you have to explain it well," he says. "If the person presenting your work does not have his or her head wrapped around your idea completely and there are ten executives throwing out questions, that person will not be ready to sell your idea."

Ⓓ = Design Firm
Ⓒ = Client

LOGO SEARCH

Keywords **Crests**

Type: ◯ Symbol ◯ Typographic ◯ Combo ● All

①

②

③

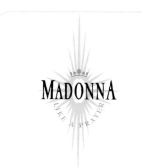

④

⑤

	A	**B**	**C**	**D**
1				
2				
3				
4				
5				

1A Ⓓ Sayles Graphic Design, Inc. Ⓒ Barrick Roofing 1B Ⓓ Chase Design Group Ⓒ Geffen Records 1C Ⓓ Gardner Design Ⓒ Cattleman's Reserve 1D Ⓓ Howalt Design Studio, Inc. Ⓒ Work, Inc.

2A Ⓓ Sayles Graphic Design, Inc. Ⓒ Artcraft Printing 2B Ⓓ Tim Frame Ⓒ Clutch Graphic 2C Ⓓ Sabingrafik, Inc. Ⓒ M. G. Swing Company 2D Ⓓ Chase Design Group Ⓒ Crave Entertainment

3A Ⓓ Gardner Design Ⓒ Excel Corporation 3B Ⓓ Sayles Graphic Design, Inc. Ⓒ Basil Prosperi 3C Ⓓ Willoughby Design Group Ⓒ Willoughby Design Group 3D Ⓓ Howalt Design Studio, Inc. Ⓒ Work, Inc.

4A Ⓓ Hornall Anderson Ⓒ U.S. Cigar 4B Ⓓ Gardner Design Ⓒ Jay Bailey 4C Ⓓ Willoughby Design Group Ⓒ O'Brien Pharmacy 4D Ⓓ Jeff Fisher LogoMotives Ⓒ W.C. Winks Hardware 5A Ⓓ Sabingrafik, Inc. Ⓒ Turner Entertainment

5B Ⓓ Howalt Design Studio, Inc. Ⓒ Work, Inc. 5C Ⓓ Howalt Design Studio, Inc. Ⓒ Main St. Beer Co. 5D Ⓓ Gardner Design Ⓒ Loft 150

A　　　　**B**　　　　**C**　　　　**D**

LOGO SEARCH

Keywords **Sports**

Type: ◯ Symbol　◯ Typographic　◯ Combo　⦿ All

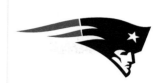 **❶**

 ❷

 ❸

 ❹

 ❺

1

2

3

4

5

①

②

③

④

⑤

1A D Rickabaugh Graphics C Big East Conference 1B D Rickabaugh Graphics C NBA Properties 1C D Chase Design Group C NBA 1D D Rickabaugh Graphics C Big East Conference 2A D Ken Shafer Design C WNBA 2B D Ken Shafer Design C NBA 2C D Rickabaugh Graphics C Atlas Color Imaging 2D D Rickabaugh Graphics C NBA Properties 3A D Sibley Peteet Design C Joefan.net 3B D Mires C Nike, Inc. 3C D Mires C Nike, Inc. 3D D Vanderbyl Design C The Court 4A D Rodgers Townsend C Rodgers Townsend 4B D Rodgers Townsend C Rodgers Townsend 4C D Dennis Purcell Design C Fox Racing 4D D Rodgers Townsend C East 3 5A D Ken Shafer Design C The Richards Group 5B D Plumbline Studios C Callan Fitness 5C D Sayles Graphic Design, Inc. C Target 5D D Elixir Design C Athleta

Made on Earth
Multi-Logo Identity

Jay Vigon Design, Studio City, CA

Jay Vigon compares the doodling he does to unearth his slightly bizarre and very charming Made on Earth characters to automatic writing.

"I am not thinking about what I am doing," says the MOE brand founder. "The shape emerges, and only then do I start to think about it."

Made on Earth is what you might call an accidental brand. Vigon and his wife Margo opened a retail store that they intended to serve primarily as a gallery for their work, not as an incubator for a brand. Sales of clothing and other items imprinted with their tribe of Made on Earth characters and their saucy messages were strong, however. Each message, such as "Boys will be boys," "It's good to be king," "Crybaby," or "Sleepy kitty," has its own character or graphic that appeals to shoppers visiting the store and the company's Web site. Sales figures have topped a million dollars, which proves, Vigon says, that there is something in the MOE mix for just about everyone.

And the brand continues to develop. There is an ebb and flow to the popularity of some of the characters, Vigon says. In essence, the Made on Earth identity is based on dozens of logos, some of which have come and gone over time. One cornerstone of the brand is Clever Girl—half-cat, half-girl, and 100 percent sass.

"I drew this character a long time ago, but it didn't have a name. I just hung it on the wall of my studio and for three or four months, I just thought about it. Then one day 'Clever Girl' just popped into my head, and I scribbled that on the art. Somebody from the store saw it and loved it. That's usually how these things work," Vigon explains.

Using multiple logos under the umbrella of the MOE brand is not traditional for such a small company. Usually, a company hangs everything on a single mark that it hopes will be absolutely unforgettable and permanent. The fluidity of MOE's identity has been a hit with individual consumers, but now Jay and Margo are closing the retail store and moving their operation into wholesale and its requisite licensing, the next logical step.

"When you are shopping for licensing, you need characters with good track records, which 'Clever' has," says Vigon. "We know we will have to pare down the list. We have about twelve characters now and will study their trends. If one doesn't hold up, we will pull it. We will also test two or three new marks each year."

A **B** **C** **D**

🅓 = Design Firm
🅒 = Client

LOGO SEARCH

Keywords **Heads**

Type: ⚪ Symbol ⚪ Typographic ⚪ Combo ⦿ All

①

②

BC·O

Spartan Development Group
INCORPORATED

③

MERC
DELIVERY

④

FOREVIEW

⑤

1C 🅓 Sabingrafik, Inc. 🅒 KidsArts San Diego 1D 🅓 Visible Ink Design 🅒 Visible Ink Design 2A 🅓 Chermayeff & Geismar, Inc. 🅒 Public Broadcasting Service 2B 🅓 Sackett Design 🅒 Biff Henderson
2C 🅓 James Lienhart Design 🅒 The Museum of Science and Industry 2D 🅓 Richards Brock Miller Mitchell & Associates 🅒 Dallas Independent School District 3A 🅓 Simon & Goetz Design 🅒 Brandcommunication-one
3B 🅓 Miaso Design 🅒 Spartan Development Group, Inc. 3C 🅓 Prejean LoBue 🅒 Centurion Technologies 3D 🅓 Richards Brock Miller Mitchell & Associates 🅒 The MS Foundation 4A 🅓 Chase Design Group 🅒 Toth Advertising
4B 🅓 Chermayeff & Geismar, Inc. 🅒 Indian Head 4C 🅓 Dotzero Design 🅒 Merc Delivery 4D 🅓 Beth Singer Design 🅒 Association of Maternal & Child Health Programs 5A 🅓 Planet Propaganda 🅒 LaMop
5B 🅓 Grapefruit Design 🅒 Foreview LLC 5C 🅓 Felixsockwell.com 🅒 Skin Cueticals 5D 🅓 Dogstar 🅒 *Cigar Aficionado*

①

②

③

④

⑤

	A	**B**	**C**	**D**	
1					
2					
3					
4					
5					

	A	**B**	**C**	**D**
1				
2				
3				
4				
5				

Ⓐ	Ⓑ	Ⓒ	Ⓓ	
				①
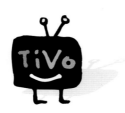				**②**
				③
				④
				⑤

Junior Cattle Baron's Ball
Event Identity

Jon Flaming Design, Dallas, TX

The Cattle Baron's Ball is a much-anticipated annual social event in Dallas, as is its offspring, the Junior Cattle Baron's Ball. First held in 1974, both benefit the area's American Cancer Society chapter. Whereas the Cattle Baron's Ball is a formal affair for well-heeled grown-ups, the Junior version is strictly for kids and includes a rodeo, pony rides, rodeo clowns, trick roping, and more.

Jon Flaming of Jon Flaming Design created the invitations for both events in 2001. Even though the balls are held annually, the designer basically had to start from scratch because the previous year's designs had been all-type treatments.

The work that comes through Flaming's studio is split between design and illustration, but even his identities tend to have an illustrative nature. This project was no exception.

"I wanted [the identity for the junior ball] to be like something you'd see in a little kid's picture book, fun for kids and adults alike," Flaming explains. "I've always liked the 1940s and '50s children's book illustrations by Leonard Weisbard and Mel Crawford and wanted to create something with that look and feel. By doing this, I felt I could come up with something that would be appealing to all ages."

Even with very corporate work, Flaming says, it is possible to be looser and please a client with a non-Paul Rand logo. Don't shut the door to creativity just because a client asks for something traditional, he advises. Instead, present a full range of moods, including some less serious things, and don't corner yourself into just presenting what the client asked for.

"Corporate clients generally want IDs that speak of tradition and conservative things. I will present them with things like that, but also with designs that are outside of the corporate box and are more illustrative—work that is more clever in its approach," he notes. "This will usually be very unexpected for them. But in lots of meetings where I have done this, I frequently hear people say, 'You know, I never thought of presenting ourselves in a different kind of way.'"

Flaming kept the main ball's identity somewhat conservative, and the junior event's ID played off of it in subtle but fun ways. The base image is of a rider holding his hat and a flag aloft while sitting astride a rearing horse. On the junior ball invitation, the words "Let's Rodeo" were added to the flag, as were suggestions of an arena, audience, and blue sky. It has the look of a setting a child would really like to visit, the designer says.

"I like to present images that I like, things that I think would look really cool," Flaming says. "Clients may say that they don't want that, but it doesn't hurt to explore. By doing that, it may actually solidify in their heads that this is not the way to go. But then again, it may turn out to be perfect."

⊙ = Design Firm
⊙ = Client

LOGO SEARCH

Keywords **People**

Type: ○ Symbol ○ Typographic ○ Combo ● All

ELLEN KNABLE & ASSOC

DIE WORKS

PREMIUM
INCREASES SMILEAGE
OPEN 24 HRS 7 DAYS

Neiman Marcus NM 90 TEXAS
THE CROSSROADS

scienceworks museum

light GEAR

MOTO SUGAI

CA
CALIFORNIA
CENTER FOR
THE ARTS
ESCONDIDO

WELLSTEADS
W
Your healthy
alternative to fast food.

SIDEWAYS
.com

RADIO ⊙ VISION

1

2

3

4

5

1A Ⓓ Chase Design Group Ⓒ Dave Thomas 1B Ⓓ Jon Flaming Design Ⓒ Objex, Inc. 1C Ⓓ Howalt Design Studio, Inc. Ⓒ Work, Inc. 1D Ⓓ Chase Design Group Ⓒ Calypso Films 2A Ⓓ Jon Flaming Design Ⓒ Skateboarder

2B Ⓓ MB Design Ⓒ Pacific Marine Foundation 2C Ⓓ Jon Flaming Design Ⓒ Mirella Films 2D Ⓓ Jon Flaming Design Ⓒ Le Gourmand 3A Ⓓ Jon Flaming Design Ⓒ Bowling Team 3B Ⓓ Bright Strategic Design Ⓒ Shipper.com

3C Ⓓ Design and Image Ⓒ The Color People 3D Ⓓ Triple 888 Studios Ⓒ Select Health 4A Ⓓ Be Design Ⓒ Worldwise, Inc. 4B Ⓓ Jon Flaming Design Ⓒ Shooting Star Ranch 4C Ⓓ Artomat Design Ⓒ Propaganda

4D Ⓓ Hornall Anderson Ⓒ Care Future 5A Ⓓ Gardner Design Ⓒ Screen for Success 5B Ⓓ Woodhead International Ⓒ Community Fund 5C Ⓓ Henderson Tyner Art Co. Ⓒ Little Theater

5D Ⓓ Chermayeff & Geismar, Inc. Ⓒ Active Ageing Association

	A	B	C	D
1				
2				
3				
4				
5				

A **B** **C** **D**

 1

CIBOLA HASTINGS FILTERS

 2

 3

BARMON
body ~ soul ~ mind

 4

Spectria aqualung deepfunk records BALANCE

 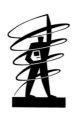 **5**

Monadnock VECTIS Group FAMILY WALK

①

②

③

④

⑤

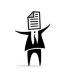

P L A N I G E N T

 ①

AUSTIN SKIERS

 ②

 ③

 ④

 ⑤

1A Ⓓ Grapefruit Design Ⓒ Planigent LLC 1B Ⓓ Howalt Design Studio, Inc. Ⓒ Virgin Records 1C Ⓓ Howalt Design Studio, Inc. Ⓒ Howalt Design 1D Ⓓ Howalt Design Studio, Inc. Ⓒ Fairfax Co., VA

2A Ⓓ Howalt Design Studio, Inc. Ⓒ Benedictine H.S. 2B Ⓓ Dogstar Ⓒ Roaring Tiger Films 2C Ⓓ Howalt Design Studio, Inc. Ⓒ Austin Skiers 2D Ⓓ Howalt Design Studio, Inc. Ⓒ Work, Inc.

3A Ⓓ Miriello Grafico, Inc. Ⓒ San Diego Crew Classic 3B Ⓓ Hoyne Design Ⓒ TheLounge.com.au 3C Ⓓ Prejean LoBue Ⓒ Old El Paso 3D Ⓓ Howalt Design Studio, Inc. Ⓒ Washington Elementary School

4A Ⓓ Howalt Design Studio, Inc. Ⓒ PledgeAllegiance.net 4B Ⓓ Howalt Design Studio, Inc. Ⓒ Scout 4C Ⓓ Sayles Graphic Design, Inc. Ⓒ USA Network 4D Ⓓ Howalt Design Studio, Inc. Ⓒ Levi Strauss & Co., Inc.

5A Ⓓ Sabingrafik, Inc. Ⓒ Schiedermayer and Associates 5B Ⓓ Mitre Design/Henderson Tyner Art Co. Ⓒ Hanes Printables 5C Ⓓ Jeff Fisher LogoMotives Ⓒ DataDork.com 5D Ⓓ Willoughby Design Group Ⓒ Bagel & Bagel

1

2

3

4

5

1A Ⓓ Jon Flaming Design Ⓒ Arizona Jeans 1B Ⓓ Jon Flaming Design Ⓒ Cattle Baron's Ball 1C Ⓓ Jon Flaming Design Ⓒ Camp Mak-A-Dream 1D Ⓓ Sandstrom Design Ⓒ Artsy Fartsy Productions

2A Ⓓ Made On Earth Ⓒ Four Hundred Drawing 2B Ⓓ Made On Earth Ⓒ Four Hundred Drawing 2C Ⓓ Made On Earth Ⓒ Four Hundred Drawing 2D Ⓓ Made On Earth Ⓒ Four Hundred Drawing

3A Ⓓ Made On Earth Ⓒ Four Hundred Drawing 3B Ⓓ Made On Earth Ⓒ Four Hundred Drawing 3C Ⓓ Felixsockwell.com Ⓒ Starwood 3 3D Ⓓ Felixsockwell.com Ⓒ Bob 4A Ⓓ Howalt Design Studio, Inc. Ⓒ Richmond Ballet

4B Ⓓ Felixsockwell.com Ⓒ TV Guide 4C Ⓓ Howalt Design Studio, Inc. Ⓒ Wellsteads 4D Ⓓ Studio Rayolux Ⓒ DrunkinSeattle.com 5A Ⓓ Felixsockwell.com Ⓒ Felix Sockwell 5B Ⓓ Henderson Tyner Art Co. Ⓒ Hanes

5C Ⓓ Wages Design Ⓒ SurfIT.com 5D Ⓓ Wages Design Ⓒ Prevail

	A	B	C	D	

 1

 trend® **2**

 GLORY **3**

 4

FUSION OPTIMA VIZIWORX **5**

1A Ⓓ Jon Flaming Design Ⓒ Elizabeth.Tailor 1B Ⓓ Brian Sooy & Co. Ⓒ Cleveland Clinic 1C Ⓓ Felixsockwell.com Ⓒ Pop Sci 1D Ⓓ Felixsockwell.com Ⓒ None 2A Ⓓ Felixsockwell.com Ⓒ Fake Pearl Head
2B Ⓓ SPATCHURST Ⓒ National Museum of Australia 2C Ⓓ Wages Design Ⓒ American Craft Council's Craft Fair Atlanta 2D Ⓓ Pogon Ⓒ Trend Sport System 3A Ⓓ Cato Purnell Partners Ⓒ Syney Breast Cancer Institute
3B Ⓓ Gardner Design Ⓒ Glory 3C Ⓓ Felixsockwell.com Ⓒ None 3D Ⓓ Felixsockwell.com Ⓒ None 4A Ⓓ Felixsockwell.com Ⓒ None 4B Ⓓ Felixsockwell.com Ⓒ None 4C Ⓓ Felixsockwell.com Ⓒ None
4D Ⓓ Felixsockwell.com Ⓒ None 5A Ⓓ Mires Ⓒ Agassi Enterprises 5B Ⓓ Braue; Branding & Corporate Design Ⓒ Optima Wirtschaftsfoerderungskuratorium 5C Ⓓ James Lienhart Design Ⓒ Governors Commission
5D Ⓓ Gardner Design Ⓒ ViziWorx Enhanced Television

125

A **B** **C** **D**

1

2

3

4

5

1

2

3

4

5

1A ⒟ Dotzero Design ⒢ Do It For Peace 1B ⒟ Dotzero Design ⒢ Do It For Peace 1C ⒟ Dan Stiles Design ⒢ Adventure Music 1D ⒟ Design One ⒢ Handmade in America 2A ⒟ Chase Design Group ⒢ Warner Bros. Records 2B ⒟ Chermayeff & Geismar, Inc. ⒢ United States Department of Interior 2C ⒟ Brian Sooy & Co. ⒢ Amber Sooy, LMT 2D ⒟ Gardner Design ⒢ Wichita Promise 3A ⒟ Kellum McClain Inc. ⒢ VH1 3B ⒟ Art Chantry ⒢ None 3C ⒟ Felixsockwell.com ⒢ Fake Spot 3D ⒟ Pat Taylor Inc. ⒢ Hand Real Estate 4A ⒟ Felixsockwell.com ⒢ advertising age 4B ⒟ Dogstar ⒢ International Center for Ethics 4C ⒟ Sabingrafik, Inc. ⒢ AIRS 4D ⒟ Sabingrafik, Inc. ⒢ Found Stuff Paperworks 5A ⒟ Gardner Design ⒢ Powerhouse 5B ⒟ Associated Advertising Agency, Inc. ⒢ Wichita Anesthesiology Chartered 5C ⒟ Sandstrom Design ⒢ Clean Water Oregon 5D ⒟ Felixsockwell.com ⒢ JWT, Johnson & Johnson

The Pageant
Interior Design and Identity

Kiku Obata & Company, St. Louis, MO

Kiku Obata & Company recently completed an identity and architectural/interior design project that afforded it a unique opportunity: to design a completely new office space for itself.

The Pageant is a brand-new building in St. Louis's eclectic "Loop" neighborhood. The 50,000-square-foot (4,645-square-meter), three-story building has four components: The Pageant, a 33,000-square-foot (3,066-square-meter) live entertainment club; The Halo Bar; two street-level retail spaces; and 14,000 square feet (1,301 square meters) of office space now occupied by Kiku Obata's team.

Obata's client, developer Joe Edwards, wanted to create a vibrant music venue that would become a city landmark. His brick-and-stucco building was designed to match the neighborhood, and in fact it looks almost as if it had been renovated, not newly built. Kiku Obata's designers created its remarkable marquee, a classic neon theater sign that glows invitingly against the building's yellowish color.

But the interior design and logo of The Pageant are anything but classic. "The logo was meant to be dynamic and really move," explains principal Kiku Obata. Below the name, a circular shape mimics a spotlight to highlight the new hot spot's location in the Loop. "The letters on the logo feel like they are moving," Obata says. "'Grooves and moves, slams and jams, hip and hot, shimmies and shakes' are all verbs we used as visual cues."

The designers applied the same "action verb" mentality to the business cards they designed for the client: "Joe Edwards's card reads 'Joe Edwards manages The Pageant,'" says Obata, "and the custodian for the place would have a card that says, 'John Doe cleans The Pageant.'"

They continued the same sense of physical activity inside The Pageant. Everywhere, there is color. The ceilings are a dark purple-blue, except in the bar, where it is a rich, golden yellow. Bright hues that accent the stairs and exits make way-finding simple, even when the lights are low. The space is designed to hold many different seating arrangements, depending on whether there is a heavy metal band on stage or the Rams football game is being shown on giant screens when the team is out of town.

Obata's firm's office space takes its design cues from The Pageant. References to performance are everywhere, with scaffolding, backdrops, and stage lighting part of the scheme. Also, a huge green curtain very like a stage curtain hides a storage area.

Whether designing an interior space or an identity, Obata says it is crucial to define what kind of experience is being offered. "You must understand the special qualities of the company, individual, or space, and then be able to translate that understanding into materials and sequencing," she says.

Credits
© *2002 Kiku Obata & Company*
Photographer: Jon Miller, Hedrich Blessing Photographers

LOGO SEARCH

Keywords **Mythology**

Type: ◯ Symbol ◯ Typographic ◯ Combo ⬤ All

A **B** **C** **D**

 1

 2

 3

 4

 5

1C Ⓓ Sandstrom Design Ⓒ FilmCore 1D Ⓓ Mires Ⓒ Hot Rod Hell 2A Ⓓ Gardner Design Ⓒ The Little Red Devils 2B Ⓓ Rodgers Townsend Ⓒ Bob Reuter 2C Ⓓ Made on Earth Ⓒ Necessary Evil 2D Ⓓ Sandstrom Design Ⓒ FilmCore

3A Ⓓ Mires Ⓒ Hell Racer 3B Ⓓ Made on Earth Ⓒ Necessary Evil 3C Ⓓ Chase Design Group Ⓒ Yonex 3D Ⓓ Howalt Design Studio, Inc. Ⓒ Diablo Engineering 4A Ⓓ Gardner Design Ⓒ Shift Photography

4B Ⓓ Mires Ⓒ Hell Racer 4C Ⓓ Gardner Design Ⓒ Roosevelt Halloween Compact 4D Ⓓ Jon Flaming Design Ⓒ Party Pirates 5A Ⓓ Tim Frame Ⓒ Retro Outfitters 5B Ⓓ Sabingrafik, Inc. Ⓒ Chingones

5C Ⓓ Chase Design Group Ⓒ Nike, Inc. 5D Ⓓ Art Chantry Ⓒ The Makers

129

	A	**B**	**C**	**D**
1	LINE RED	MUNDUS VULT DECIPI · CAVEAT EMPTOR · MCMXCVI	A MURDER OF CROWS	FULL BORE
2	GO AWAY GARAGE	KEITH RICHARDS AND THE X-PENSIVE WINOS	MT. PINATUBO	bone dry BEER
3	West E.P. LOW FAT SNOW SERIES		ESTRUS	BAND OF ANGELS
4				
5	ANGEL CITY FITNESS	Angel Shack	THE ANGEL NETWORK	

	A	B	C	D	
					1
					2
	THE LOS ANGELES ATHLETIC CLUB				**3**
	batgirl			RENO TECHNOLOGY	**4**
	VIKINGESKIBS MUSEET				**5**

1

2

3

4

5

1A Ⓓ Simon & Goetz Design Ⓒ Gebrüder Schaffrath 1B Ⓓ Sabingrafik, Inc. Ⓒ Turner Entertainment 1C Ⓓ Monigle Associates Inc. Ⓒ Atlas Air, Inc. 1D Ⓓ Visible Ink Design Ⓒ Arts Finance

2A Ⓓ Hornall Anderson Ⓒ Aptimus Corporation 2B Ⓓ Sandstrom Design Ⓒ Moonstruck Chocolatier 2C Ⓓ Blue Beetle Design Ⓒ CHG 2D Ⓓ Gardner Design Ⓒ Ares 3A Ⓓ Ken Shafer Design Ⓒ Fox River Paper

3B Ⓓ Sabingrafik, Inc. Ⓒ University of California San Diego 3C Ⓓ Prejean LoBue Ⓒ Disneyland Paris - Disney 3D Ⓓ Sabingrafik, Inc. Ⓒ Harcourt & Co. 4A Ⓓ Richards Brock Miller Mitchell & Associates Ⓒ WebGenie

4B Ⓓ Sabingrafik, Inc. Ⓒ Harcourt Brace & Co. 4C Ⓓ Sabingrafik, Inc. Ⓒ Harcourt Brace & Co. 4D Ⓓ Sabingrafik, Inc. Ⓒ Harcourt Brace & Co. 5A Ⓓ Felixsockwell.com Ⓒ Oprah 5B Ⓓ Felixsockwell.com Ⓒ Oprah

5C Ⓓ Felixsockwell.com Ⓒ Oprah 5D Ⓓ Howalt Design Studio, Inc. Ⓒ *People* Magazine

In late 2000, El Paso Energy Corporation—one of the largest natural gas companies in the world—had acquired a competitor, was solidifying new business, and was looking for a way to articulate its unique vision and build its reputation on Wall Street. In short, it needed a global brand that would support its merged businesses and help it become a leader in the global energy market.

The first thing the Sterling Group did after accepting the challenge was to interview executives, customers, analysts, and shareholders to understand the roots, passions, and visions of El Paso. From this process emerged a new brand positioning statement: The new path to energy value.

"After all, *El Paso* means *the pass*," notes Marcus Hewitt, managing partner and creative director for the Sterling Group. "This positioning statement captures the new approach that they take to create value in the energy value."

The second step was to recommend shortening the company's name to simply El Paso Corporation, which places more emphasis on *El Paso* as a name instead of the energy modifier. Pushing the words together felt much more integrated and compact. The latter is especially helpful when the name must be combined with that of one of the many business units El Paso operates.

"Some unit names were short, some were long," says Hewitt. "With the old identity, the unit name got most of the attention; now *El Paso* gets more emphasis. This readdresses the problem of the hierarchy of the single brand."

To design the actual logo, Sterling designers focused on the notion of pathways. Every trial they did contained some sort of path, either depicted through negative spaces in the letterforms or shown in an actual graphical representation. In the version that was eventually selected, an upwardly pointing arrow leading off the letter *l* introduces the concept of a path.

Blue was selected as the new corporate color for its more contemporary look than the red and black the company had used, and for its subtle suggestion of the clean flame of natural gas. The custom sans serif face chosen for the design is also clean and approachable.

Old identity

The lesson Hewitt took away from the project was that even a very large corporation can take giant steps, given the proper guidance.

"They changed the identity from all uppercase to all lowercase letters, from red to blue, and even changed their name. That's because their management has a very flat organization, and they went with their gut," he says. "Usually, large corporations constantly adjust in small ways. But if we can make our advice simple, big changes are possible."

LOGO SEARCH

Keywords **Birds**

Type: ◯ Symbol ◯ Typographic ◯ Combo ◉ All

	A	**B**	**C**	**D**	
					1
					2
					3
					4
					5

1A ▶ Bird Design ◉ Bird Design 1B ◉ Gardner Design ◉ Neufeldt's 1C ▶ Dogstar ◉ Gregory Freeze 1D ▶ Mitre Design/Henderson Tyner Art Co. ◉ Habitat For Humanity 2A ▶ Balance ◉ Ambleside School
2B ◉ Sibley Peteet Design ◉ Tequila Mockingbird 2C ▶ Felixsockwell.com ◉ The Old Crow 2D ▶ Pogon ◉ Idea Plus DDB 3A ◉ Gardner Design ◉ Fat Chance Bird Food 3B ◉ Prejean LoBue ◉ The Kitchen, Inc.
3C ▶ Artomat Design ◉ Seattle Symphony 3D ▶ Gardner Design ◉ John Crowe Photography 4A ▶ Chermayeff & Geismar, Inc. ◉ Savories 4B ◉ Chermayeff & Geismar, Inc. ◉ St. Joe Real Estate
4C ▶ Klauddesign ◉ Microsoft 4D ▶ Lexicon Graphix, Inc. ◉ Terakeet 5A ▶ GTA - Gregory Thomas Associates ◉ Air Rescue 5B ◉ CRE8 Communications, Inc. ◉ Abused Adult Resource Center
5C ▶ Associated Advertising Agency, Inc. ◉ Malisa's Hope 5D ▶ Dotzero Design ◉ Do It For Peace

135

1

CANYON HILLS

QUAIL HILL

2

CAMDEN

3

4

5

1A Ⓓ Sabingrafik, Inc. Ⓒ Canyon Hills 1B Ⓓ Sabingrafik, Inc. Ⓒ Canyon Hills 1C Ⓓ Sabingrafik, Inc. Ⓒ Pardee Homes 1D Ⓓ Miriello Grafico, Inc. Ⓒ The Irvine Company

2A Ⓓ Associated Advertising Agency, Inc. Ⓒ Occidental Management 2B Ⓓ Chase Design Group Ⓒ Hum 2C Ⓓ Monigle Associates Inc. Ⓒ Camden Properties 2D Ⓓ Cincodemayo Ⓒ Direct Link

3A Ⓓ SPATCHURST Ⓒ Capitol Theatre 3B Ⓓ Chermayeff & Geismar, Inc. Ⓒ National Broadcasting Company 3C Ⓓ Chase Design Group Ⓒ Hard Rock Hotel and Casino 3D Ⓓ Dogstar Ⓒ Peacock Music Studio

4A Ⓓ Dotzero Design Ⓒ Wichita Blues Society 4B Ⓓ Modern Dog Communications Ⓒ One Reel 4C Ⓓ Webster Design Associates Inc. Ⓒ Thunderbird Grill 4D Ⓓ Gardner Design Ⓒ Corrington High School

5A Ⓓ Prejean LoBue Ⓒ Red Hot Pepper Sauce 5B Ⓓ Sandstrom Design Ⓒ Chickenville 5C Ⓓ Luce Beaulieu Ⓒ restaurant Le Poulet Grillé 5D Ⓓ Jon Flaming Design Ⓒ Early Bird Records

1

2

3

4

5

1A Ⓓ cincodemayo Ⓒ Cerro Brujo 1B Ⓓ Howalt Design Studio, Inc. Ⓒ Hanschell Innis 1C Ⓓ Sandstrom Design Ⓒ Burgerville 1D Ⓓ Hornall Anderson Ⓒ Capons Rotisserie Chicken

2A Ⓓ Gardner Design Ⓒ Wichita Farm and Art Market 2B Ⓓ Pat Taylor Inc. Ⓒ Night Owl Security 2C Ⓓ t.b.g. Design Ⓒ The Owl and the Pussycat 2D Ⓓ Vanderbyl Design Ⓒ Bedford Properties 3A Ⓓ Tharp Did It Ⓒ Bayshore Press

3B Ⓓ Gardner Design Ⓒ Kansas Health Foundation 3C Ⓓ Sabingrafik, Inc. Ⓒ Brightwater 3D Ⓓ Chermayeff & Geismar, Inc. Ⓒ Desert Ranch 4A Ⓓ Be Design Ⓒ Slave 4B Ⓓ Jeff Fisher LogoMotives Ⓒ Jeff Fisher LogoMotives

4C Ⓓ Chermayeff & Geismar, Inc. Ⓒ Crane and Company 4D Ⓓ Sandstrom Design Ⓒ Blue Heron Ale 5A Ⓓ Chermayeff & Geismar, Inc. Ⓒ Key Sabinal 5B Ⓓ Marcus Lee Design Ⓒ Hobsons Bay City Council

5C Ⓓ Evenson Design Group Ⓒ Discovery Island 5D Ⓓ Sabingrafik, Inc. Ⓒ San Diego Zoo

LOGO SEARCH

D = Design Firm
C = Client

Keywords | Fish/Bugs/Reptiles

Type: ◯ Symbol ◯ Typographic ◯ Combo ⦿ All

ARCHIPELAGO

TRITON

FRANKSTON CITY

Fat Fish Films

SHARK BITES

SH RK
JERKY

MAKO
SOFTWARE

KONOBA
Pantagana

Tamarindo Pacifico

Chaos Lures

THE FOOD CHAIN

SUPMARINE

NELAYAN

1C Ⓓ Felixsockwell.com Ⓒ Turtle Creek Chorale 1D Ⓓ Addis Ⓒ Archipelago 2A Ⓓ Chermayeff & Geismar, Inc. Ⓒ Tennessee Aquarium 2B Ⓓ Sabingrafik, Inc. Ⓒ The Masters Group

2C Ⓓ Richards Brock Miller Mitchell & Associates Ⓒ Triton 2D Ⓓ Sibley Peteet Design Ⓒ Center For Marine Conservation 3A Ⓓ Marcus Lee Design Ⓒ Frankston City Council

3B Ⓓ Eisenberg and Associates Ⓒ University of Arizona 3C Ⓓ Made on Earth Ⓒ Fat Fish Films 3D Ⓓ Prejean LoBue Ⓒ Atlantis Paradise Island 4A Ⓓ Triple 888 Studios Ⓒ Sundance Seafoods

4B Ⓓ Artimana Ⓒ Mako Software 4C Ⓓ Pogon Ⓒ Konoba Pantagana 4D Ⓓ Sabingrafik, Inc. Ⓒ Tamarindo Pacifico 5A Ⓓ Sabingrafik, Inc. Ⓒ Chaos Lures 5B Ⓓ Jeff Fisher LogoMotives Ⓒ Triangle Productions!

5C Ⓓ Simon & Goetz Design Ⓒ Supmarine 5D Ⓓ Prejean LoBue Ⓒ Hyatt International - Grand Hyatt Bali

A **B** **C** **D**

 1

 2

3

4

5

1A Ⓓ Dogstar Ⓒ Catharine Fishel 1B Ⓓ Dogstar Ⓒ Black Warrior Cahaba Rivers Land Trust 1C Ⓓ Mitre Design Ⓒ Pam Fish, production/design 1D Ⓓ Chermayeff & Geismar, Inc. Ⓒ National Aquarium Baltimore

2A Ⓓ Tharp Did It Ⓒ Steamer's Grillhouse 2B Ⓓ Chermayeff & Geismar, Inc. Ⓒ New England Aquarium 2C Ⓓ John Evans Design Ⓒ Salt Grass Steakhouse 2D Ⓓ Gardner Design Ⓒ Piranha Manufacturing

3A Ⓓ Bel Bare Ⓒ Kailis Bros 3B Ⓓ Gardner Design Ⓒ Kona Coast 3C Ⓓ Sayles Graphic Design, Inc. Ⓒ Aventis 3D Ⓓ Gardner Design Ⓒ Great Lodge 4A Ⓓ CRE8 Communications, Inc. Ⓒ Green River Stone Company

4B Ⓓ Chase Design Group Ⓒ Heal the Bay 4C Ⓓ Gardner Design Ⓒ Big Fish Bar 4D Ⓓ Gardner Design Ⓒ Go Away Garage 5A Ⓓ Made on Earth Ⓒ Made on Earth 5B Ⓓ Gardner Design Ⓒ Buzz Cut Lawn Care

5C Ⓓ Gardner Design Ⓒ KTBN Kansas Technology Business Network 5D Ⓓ Simon & Goetz Design Ⓒ Red Ant

1

2

3

4

5

1A Ⓓ Klauddesign Ⓒ Make a Wish 1B Ⓓ GTA - Gregory Thomas Associates Ⓒ Monarch Films 1C Ⓓ Sayles Graphic Design, Inc. Ⓒ McArthur Company 1D Ⓓ Woodhead International Ⓒ Betty Blue

2A Ⓓ Mitre Design Ⓒ Good Lawn 2B Ⓓ Simon & Goetz Design Ⓒ Lakepaper 2C Ⓓ Art Chantry Ⓒ Estrus Records 2D Ⓓ Sabingrafik, Inc. Ⓒ Sabingrafik, Inc. 3A Ⓓ Howalt Design Studio, Inc. Ⓒ Webdrop

3B Ⓓ Chase Design Group Ⓒ Virgin Records 3C Ⓓ Made on Earth Ⓒ Ariat 3D Ⓓ Gardner Design Ⓒ Go Away Garage 4A Ⓓ Chermayeff & Geismar, Inc. Ⓒ Clay Adams 4B Ⓓ Wages Design Ⓒ Atlanta Medical Group

4C Ⓓ Artimana Ⓒ Modo Arquitectura 4D Ⓓ James Lienhart Design Ⓒ Chameleon Color Crafts 5A Ⓓ Be Design Ⓒ Cost Plus World Market 5B Ⓓ Liska + Associates Communication Design Ⓒ Reptile Artists Agent

5C Ⓓ Chase Design Group Ⓒ Ammirati Puris Lintas 5D Ⓓ DK Design Ⓒ Six Flags Over Texas

The Ocean Conservancy
Identity Design

MetaDesign, San Francisco, CA

The designers explored the concept of an "eco-circle." The world starts with water and works its way through all of the many species the Conservancy defends. Graphical, nongeographic representations of sea life placed in a cycle of life felt inspirational and spoke of science, and the completed circle implied results.

The finished, color identity further underlines the notion of water. In fact, varnishes are used on the stationery and collateral pieces to imply the transparency of water.

"All of these allusions help people understand the organization better. It helps senior management to articulate the group's goals—it makes what they are doing authentic," says Lowe.

"It was inspiring for us to be a part of this," he adds. "We are talking about an organization that has a lot of ability to effect change. Giving them the ability to make big changes could really help a lot of people, and in the end, keep our oceans clean and wild. "When you can make this kind of difference as a designer, you feel pretty good about what you're doing with your life."

MetaDesign faced a cadre of substantial obstacles when it stepped in in early 2001 to help the then-named Center for Marine Conservation find a new and more global identity.

The first problem was that a new and less environmentally friendly presidential administration would likely be coming into power later that year, which could jeopardize funding and volunteer support for the thirty-year-old nonprofit. Second, any new identity had to represent all forms of sea life, plant and animal, in every part of the world. And third—perhaps the greatest obstacle—was that to attract heartfelt support from the general public, the new identity would have to be emotive, which could be a tough sell to an organization steeped in science.

MetaDesign, partnering with naming strategist Metaphore (which has no formal relation to MetaDesign), began by evaluating the organization's name and brand attributes, which they found did not adequately map the organization's global vision and mission. After about a month of research and strategic development, Metaphore presented the name *The Ocean Conservancy* to the board. The result was unanimous approval.

"We discovered that one figure just couldn't represent the richness of life within the oceans, and really had no chance of satisfying the many constituents that the Ocean Conservancy needs to speak to," recalls Rick Lowe, creative director for MetaDesign.

Credits

Project Design and Strategist: David Peters; Creative Director: Rick Lowe; Associate Creative Director: Terry Irwin; Lead Designer: Neil Sadler; Designers: J. J. Ha, Michael Lin; Implementation Designer: Regina Serrambana; Project Manager: Alison Moskal

A **B** **C** **D**

1

D = Design Firm
C = Client

LOGO SEARCH

Keywords **Animals**

Type: ○ Symbol ○ Typographic ○ Combo ● All

2

3

4

5

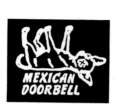

1

2

3

4

5

	A	**B**	**C**	**D**
1				
2				
3				
4			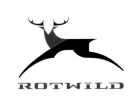	
5				

1A 🅓 Art Chantry 🅒 Chuckie-Boy Records 1B 🅓 Made on Earth 🅒 Made on Earth 1C 🅓 Howalt Design Studio, Inc. 🅒 Roseville Cougars 1D 🅓 After Hours Creative 🅒 Max and Lucy 2A 🅓 Made on Earth 🅒 Made on Earth
2B 🅓 Phinney/Bischoff Design 🅒 House Torrefazione Italia 2C 🅓 Chase Design Group 🅒 Leaping Manx 2D 🅓 Dogstar 🅒 The Cat 3A 🅓 Gardner Design 🅒 The Independent School 3B 🅓 Sabingrafik, Inc. 🅒 San Diego Zoo
3C 🅓 Gardner Design 🅒 PrairieFest 3D 🅓 Ken Shafer Design 🅒 The Richards Group, Team Mad Dog 4A 🅓 Sabingrafik, Inc. 🅒 San Diego Gas & Electric 4B 🅓 Vanderbyl Design 🅒 Coyote Books
4C 🅓 Simon & Goetz Design 🅒 ADP Engineering GMBH/Rotwild 4D 🅓 Sabingrafik, Inc. 🅒 Harcourt & Co. 5A 🅓 Sabingrafik, Inc. 🅒 San Diego Zoo 5B 🅓 Richards Brock Miller Mitchell & Associates 🅒 Oryx
5C 🅓 Richards Brock Miller Mitchell & Associates 🅒 The Dallas Zoo 5D 🅓 Hornall Anderson 🅒 Gang of Seven

①

②

③

④

⑤

	A	**B**	**C**	**D**
1				
2				
3				
4				
5				

1A Ⓓ Gardner Design Ⓒ Doskocil Meats 1B Ⓓ Jeff Fisher LogoMotives Ⓒ Crossings at The Riverhouse 1C Ⓓ Gardner Design Ⓒ Hoch Haus Cabin 1D Ⓓ Howalt Design Studio, Inc. Ⓒ Burly Bear Television

2A Ⓓ Prejean LoBue Ⓒ Southwest Missouri State University 2B Ⓓ Howalt Design Studio, Inc. Ⓒ Burly Bear Television 2C Ⓓ Balance Ⓒ Koala 2D Ⓓ Sabingrafik, Inc. Ⓒ Big Behr Design Co.

3A Ⓓ Vanderbyl Design Ⓒ California Conservation Corp. 3B Ⓓ Richards Brock Miller Mitchell & Associates Ⓒ Bearsouls 3C Ⓓ Willoughby Design Group Ⓒ Peruvian Connection 3D Ⓓ Addis Ⓒ IDG Books

4A Ⓓ James Lienhart Design Ⓒ Black Sheep Club 4B Ⓓ Sibley Peteet Design Ⓒ Quiet Time 4C Ⓓ Balance Ⓒ Hiding Place 4D Ⓓ Sayles Graphic Design, Inc. Ⓒ Beaverdale Neighborhood Association

5A Ⓓ Sayles Graphic Design, Inc. Ⓒ Raccoon River Brewing Company 5B Ⓓ Made on Earth Ⓒ Made on Earth 5C Ⓓ Prejean LoBue Ⓒ Disney Cruise Line - Disney

5D Ⓓ Richards Brock Miller Mitchell & Associates Ⓒ Young President's Organization

1

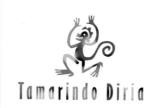
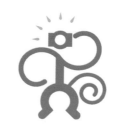
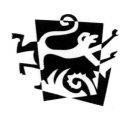

2

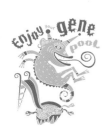
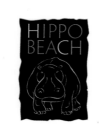

3

4

5

City of Las Vegas
Identity Design

Mires, San Diego, CA

It would be difficult to find anyone in the United States and possibly even abroad who does not know what Las Vegas is all about. But that does not mean that developing an identity for the gambling mecca was a quick solution, reports José A. Serrano, creative director for Mires, San Diego.

When the Las Vegas Convention and Visitors Bureau first asked for a new identity, the centerpiece of its existing system was an art deco–style circle with the city name set inside. In addition to desiring an updated image, the bureau wanted a mark that could be used in a broader range of applications: A circle's limitation, of course, is that it is always as tall as it wide, so rectangular, billboardlike applications were out of the question.

Still, the client wanted to retain some of the equity of the old mark. So, Serrano and his design team experimented with updating the circle, but soon moved in other directions. The difficulty lay in conveying a sense of the passion, energy, and excitement of Vegas without becoming too clichéd.

As part of their strategic approach to the identity design, Serrano and his team determined a set of criteria that would be the foundation for their concepting. This is when the promising idea of a gaming-chip image came about. Its shape would allow the new identity to draw on the equity of the previous logo, but the team could experiment with showing single chips, stacks of chips, and even chips that seemed to be in motion, among other concepts.

"We were trying to come up with a single symbol that said *Vegas,* Serrano explains. "The common denominator in gambling, whether you are playing blackjack or roulette and so on, is the poker chip. It was a symbol that would work across age-groups and genders."

The firm's solution certainly told the story of Las Vegas: Five chips house the letters in *Vegas,* laying one atop the last, like chips are spread on a gaming table. The typography they selected is clean, sharp, and modern, very much like the city it describes.

"We explored numerous typography options. Countless serifs and sans serifs were looked at just to relay the Las Vegas personality without a bug," says Serrano.

The mark can be used in black and white—positive or reversed— or it can be run in color, pulling from a flexible palette of gold, green, blue, red, and purple. Serrano feels that these colors have impact, are both basic and practical in various applications, and are compelling.

The identity succeeds, Serrano says, for aesthetic and practical reasons: It reproduces well in all media, is simple, appeals to all target audiences, and conveys the Vegas personality. But most important, he adds, is that the design creates a strong foundation on which the Vegas brand can be further defined, unified, and strengthened through other marketing strategies.

LOGO SEARCH

Keywords **Nature**

Type: ◯ Symbol ◯ Typographic ◯ Combo ⦿ All

Arcosanti Homes, Inc.

Twin Oaks

①

greentree
p i c t u r e s

consensus
H E A L T H
Integrated Choices for Whole Health

②

terra

Prime*life*

③

CANYON
HILLS

simply
Organic™

④

DOUBLEGREEN
L A N D S C A P E S

NEW LEAF
PAPER

se'madi

⑤

	A	B	C	D
1				
2				
3				
4				
5				

	A	B	C	D

 FESTIVAL OF INDIA MAGNOLIA CROSSING **Native** LANDSCAPES MARY KAY **1**

 Caboodles EXECUTIVE flowerpower GRANDIFLORUM PERFUMES **2**

 UNIVERSITY/ EXPOSITION PARK **3**

 SOMERSET COURT D'OLIVO OKLAHOMA GARDEN FESTIVAL VINA SA PESKA PODRUM PALIĆ OSNOVANO 1896 **4**

 O's xyzest **5**

1A Ⓓ Chermayeff & Geismar, Inc. Ⓒ Festival of India 1B Ⓓ Jon Flaming Design Ⓒ Neiman Marcus 1C Ⓓ Balance Ⓒ Native Landscapes 1D Ⓓ Sibley Peteet Design Ⓒ Mary Kay Cosmetics 2A Ⓓ Mires Ⓒ Caboodles

2B Ⓓ Willoughby Design Group Ⓒ Stuart Hall 2C Ⓓ Proart Graphics/Gabriel Kalach Ⓒ Flower Power 2D Ⓓ Elixir Design Ⓒ Grandiflorum Perfumes 3A Ⓓ Pat Taylor Inc. Ⓒ International Peace Garden Foundation

3B Ⓓ Chermayeff & Geismar, Inc. Ⓒ White House Conference on Children 3C Ⓓ Sayles Graphic Design, Inc. Ⓒ Pattee Enterprises 3D Ⓓ GTA - Gregory Thomas Associates Ⓒ USC

4A Ⓓ Henderson Tyner Art Co. Ⓒ Somerset Homes 4B Ⓓ Miriello Grafico, Inc. Ⓒ D'Olivo 4C Ⓓ S Design, Inc. Ⓒ Oklahoma Garden Festival Foundation 4D Ⓓ Pogon Ⓒ Podrum Palic

5A Ⓓ Hornall Anderson Ⓒ Best Cellars 5B Ⓓ Prejean LoBue Ⓒ The King Ranch Vineyard Partnership 5C Ⓓ Sibley Peteet Design Ⓒ O's Campus Cafe 5D Ⓓ Marcus Lee Design Ⓒ Xyzest

1

2

3

4

5

1A Ⓓ Sibley Peteet Design Ⓒ Tim McClure 1B Ⓓ Hornall Anderson Ⓒ Best Cellars 1C Ⓓ Sackett Design Ⓒ Nightshade Restaurant 1D Ⓓ Marcus Lee Design Ⓒ Cherry Print 2A Ⓓ Sayles Graphic Design, Inc. Ⓒ Bells Apple Orchard

2B Ⓓ Balance Ⓒ Heartsmart 2C Ⓓ Sayles Graphic Design, Inc. Ⓒ Bells Apple Orchard 2D Ⓓ Sabingrafik, Inc. Ⓒ Found Stuff Paperworks 3A Ⓓ After Hours Creative Ⓒ The Cotton Center

3B Ⓓ Prejean LoBue Ⓒ Assemblies of God Church 3C Ⓓ Gardner Design Ⓒ Midwest Ag. Board of Trade 3D Ⓓ Modern Dog Communications Ⓒ Greenwood Parks Dept. 4A Ⓓ Sabingrafik, Inc. Ⓒ Rancho Bernardo Inn

4B Ⓓ Sibley Peteet Design Ⓒ Bodhi Yoga 4C Ⓓ Dogstar Ⓒ Birmingham Ecoplex 4D Ⓓ CRE8 Communications, Inc. Ⓒ Interior Gardens 5A Ⓓ Pat Taylor Inc. Ⓒ Trees America 5B Ⓓ MB Design Ⓒ Barkley Corporation

5C Ⓓ Miriello Grafico, Inc. Ⓒ Lone Cypress Importers 5D Ⓓ Prejean LoBue Ⓒ The Callaway Bank

1

2

3

4

5

1A Ⓓ Buz Design Group Ⓒ University of Southern California 1B Ⓓ Mires Ⓒ Shea Homes 1C Ⓓ Dogstar Ⓒ Woodland Village Retirement Community 1D Ⓓ Treehouse Design Ⓒ The Cypress Center

2A Ⓓ Hornall Anderson Ⓒ Eagle Lake on Orcas Island 2B Ⓓ Evenson Design Group Ⓒ Eras Center 2C Ⓓ Mires Ⓒ Adventure 16 2D Ⓓ Sayles Graphic Design, Inc. Ⓒ Alpine Shop 3A Ⓓ Simon & Goetz Design Ⓒ ZDF

3B Ⓓ Chermayeff & Geismar, Inc. Ⓒ United States Department of Interior 3C Ⓓ Design and Image Ⓒ Land Design 3D Ⓓ BrandEquity Ⓒ Earth Shoe 4A Ⓓ Chermayeff & Geismar, Inc. Ⓒ Turning Stone Casino

4B Ⓓ Hornall Anderson Ⓒ Heavenly Stone 4C Ⓓ Sabingrafik, Inc. Ⓒ Canyon Hills 4D Ⓓ Mires Ⓒ Nextec 5A Ⓓ Cato Purnell Partners Ⓒ Docklands School of Design 5B Ⓓ Mires Ⓒ The Church of Today

5C Ⓓ Sibley Peteet Design Ⓒ Bares Capital Management 5D Ⓓ Richards Brock Miller Mitchell & Associates Ⓒ WaterDesk.com

Swinburne University Hospital
Identity Design

Watts Design, Melbourne, Australia

Swinburne University Hospital, which offers both alternative and Western medicines, was the first of its kind in Australia. Patients can receive conventional medical treatment in addition to alternative treatments such as music therapy, Reiki healing, aromatherapy, reflexology, and hydrotherapy, to name a few.

As a private hospital, Swinburne must, of course, entice customers. "They have to sell the way they heal people," explains Peter Watts, principal of Watts Design, Melbourne, Australia.

Because no other facilities had set a precedent for this category of hybrid medicine, Watts and his partner and wife, Helen Watts, were able to blaze a very different path for the hospital's identity. The obvious symbolic direction to take with the concept of East meeting West was the yin–yang, says Peter Watts.

The designers worked with the symbol until it not only had a modern, progressive feel, it also formed a modified *S* to stand for *Swinburne.* "The dot at the center could be the center of oneself and of

well-being," he explains. The typography that accompanies the logo has a calm, restful sensibility. But it also has a corporate feel: The designers did not want it to feel too "boutiquey."

Color and photography are also substantial parts of the new identity. After working through a range of color combinations, trying to find a tranquil, harmonious scheme, the team developed a palette of restful yellows and purples. The yellow represents harmony and balance, and the deep purples reflect the calm of the hospital's environment. The colors also combine well in duotones.

These colors shift from dark to light in various designs to simulate the passage from illness to wellness. The body, mind, and spirit are subtly suggested in the transitions and in the soft, layered photography.

"The tag line for the entire project was, 'Mind, body, environment,'" Watts explains. "We were able to show dreaming and healing and recovery." In some designs, monotone and color photographs are combined to reflect the soothing and positive approach of this form of healing.

The color scheme and photo combinations run throughout the facility's design elements. For instance, in the hospital's reception area, the walls are painted with the same soft colors. The graphics and hues of the identity also appear on environmental signage and uniforms.

LOGO SEARCH

Ⓓ = Design Firm
Ⓒ = Client

A **B** **C** **D**

Keywords **Shapes**

Type: ◯ Symbol ◯ Typographic ◯ Combo ◉ All

Software **Spectrum**

★ GLOBAL ★ PREFERENCE

1C Ⓓ Monigle Associates Inc. Ⓒ Software Spectrum, Inc. 1D Ⓓ Howalt Design Studio, Inc. Ⓒ Sheraton Hotels 2A Ⓓ Ken Shafer Design Ⓒ Port of Seattle 2B Ⓓ Webster Design Associates Inc. Ⓒ ACNielsen

2C Ⓓ Art Chantry Ⓒ Earth Police 2D Ⓓ Pat Taylor Inc. Ⓒ Esrig Global Gifts 3A Ⓓ Gardner Design Ⓒ Virtual Focus 3B Ⓓ Sabingrafik, Inc. Ⓒ Taylor Guitars 3C Ⓓ Planet Propaganda Ⓒ Brave World Productions

3D Ⓓ Tim Frame Ⓒ Universal Studios 4A Ⓓ Modern Dog Communications Ⓒ American Design & Manufacturing 4B Ⓓ Roman Design Ⓒ EdGate.com, Inc. 4C Ⓓ Jon Flaming Design Ⓒ Global Partners

4D Ⓓ Cronan Group Ⓒ eWorldFreight 5A Ⓓ Chermayeff & Geismar, Inc. Ⓒ Pan American Airways 5B Ⓓ Gardner Design Ⓒ La Chance International Brokerage 5C Ⓓ Sabingrafik, Inc. Ⓒ Brightwater

5D Ⓓ Sabingrafik, Inc. Ⓒ Found Stuff Paperworks

TUMBLE DRUM

OCEANPLACE

interexpo
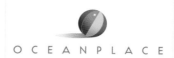

be

A X I S

BAR CELONA
RESTAURANT BAR

FRISA

MLR

COSMO TRAVELER
BY FIRST CLASS BAGGAGE

prosolis
THE SOLUTION HOUSE

FirstWorld
COMMUNICATIONS

open band

ASIACONVERGE

The adventure program

m10
mach 10 MEDIA

DOOM

①

KINTANA

CURRENTS

②

POWERTRAX

AERZONE

SafeSide

③

TeaLeaf
TECHNOLOGY

Teledesic

infab

④

SYDNEY
Super
Dome

STIR

⑤

TriActive

Invitrogen
life technologies

International Sites

SALESMARK

1A Ⓓ Cato Purnell Partners Ⓒ The Federal Group 1B Ⓓ Cronan Group Ⓒ Kintana 1C Ⓓ Lieber Cooper Associates Ⓒ Swissôtel - Chicago, Illinois 1D Ⓓ John Silver Ⓒ John Silver

2A Ⓓ Mires Ⓒ Powertrax 2B Ⓓ Cato Purnell Partners Ⓒ Neil Henson Fashion Bytes 2C Ⓓ Hornall Anderson Ⓒ Aerzone Corporation 2D Ⓓ Wages Design Ⓒ The Weather Channel

3A Ⓓ Cronan Group Ⓒ Tea Leaf Technology 3B Ⓓ Hornall Anderson Ⓒ Teledesic 3C Ⓓ Wages Ⓒ Design Infab 3D Ⓓ Proart Graphics/Gabriel Kalach Ⓒ Digital Road 4A Ⓓ Cato Purnell Partners Ⓒ Sydney Super Dome

4B Ⓓ Device Ⓒ Powertrax 4C Ⓓ Liska + Associates Communication Design Ⓒ The Interexchange Group 4D Ⓓ Planet Propaganda Ⓒ Stir 5A Ⓓ Indicia Design, Inc. Ⓒ TriActive, Inc.

5B Ⓓ Mires Ⓒ Invitrogen Life Technologies 5C Ⓓ Plumbline Studios Ⓒ International Sites 5D Ⓓ Corporate Image Consultants, Inc. Ⓒ Sales Mark, Inc.

A	B	C	D

 1

 2

 3

 4

 5

	A	**B**	**C**	**D**

1

2

3

4

5

A	B	C	D	
CLIFFSIDE ENTERTAINMENT		WORLDSONG 2002 MUSICAL SUPERCONNECTIVITY	VelociGen Inc.	**1**
glide	TalkOn	TECHNOLOGY ACHIEVEMENT AWARD 2000	tradelets.com	**2**
MultiSpeak	LUXEON	pandesic. The Internet Company from Intel and SAP		**3**
DUXFORD Imperial War Museum	CATENAS	EMBARCADERO COMMON	billerbeck SCHLAFKULTUR SEIT 1921	**4**
SUNESIS	LOYANG POINT	okamoto	energex	**5**

LOGO SEARCH

Keywords **Symbols**

Type: ○ Symbol ○ Typographic ○ Combo ● All

PENTACASAS

STRATEGIC
AIR & SPACE
MUSEUM

1C Ⓓ Gardner Design Ⓒ Wichita Festivals, Inc. 1D Ⓓ Webster Design Associates Inc. Ⓒ First National Brokerage 2A Ⓓ Pat Taylor Inc.Ⓒ Ameribus Tours

2B Ⓓ Chermayeff & Geismar, Inc. Ⓒ American Revolution Bicentennial Commission 2C Ⓓ Pat Taylor Inc. Ⓒ Wisconsin Star Publishers 2D Ⓓ Boelts/Stratford Associates Ⓒ U.S. Senior Olympics

3A Ⓓ Braue; Branding & Corporate Design Ⓒ Pentacasas Ferienhaeuser GmbH 3B Ⓓ Sibley Peteet Design Ⓒ University of Texas 3C Ⓓ Vanderbyl Design Ⓒ City of Richmond 3D Ⓓ Hornall Anderson Ⓒ Food Services of America

4A Ⓓ Webster Design Associates Inc. Ⓒ Strategic Air & Space Museum 4B Ⓓ Dotzero Design Ⓒ Star Advisors 4C Ⓓ Gardner Design Ⓒ Wichita River Festival 4D Ⓓ Wages Design Ⓒ Chick-fil-A University

5A Ⓓ Gardner Design Ⓒ Precision Datacom 5B Ⓓ Chermayeff & Geismar, Inc. Ⓒ Multicanal 5C Ⓓ Vanderbyl Design Ⓒ U.S. Air Force 5D Ⓓ Beth Singer Design Ⓒ The American Israel Public Affairs Committee

	A	**B**	**C**	**D**

 1

 2

 3

 4

 5

	A	**B**	**C**	**D**
1				Georgia State University
2				
3	DANA-FARBER CANCER INSTITUTE	SAGE		SAFE & DRUG-FREE SCHOOL RECOGNITION PROGRAM
4	HBO FILMS	HOT MUSTARD RECORDS	SLAKE JUNGLE JUICE	HELL'S ELEVATOR PROD.
5		HENDRIX		

Ⓐ	Ⓑ	Ⓒ	Ⓓ

 ❶

 ❷

 ❸

 ❹

 ❺

Tamansari Beverage
Package Design and Identity

Sabingrafik, Carlsbad, CA

Old

Like most identity designers these days, Tracy Sabin finds that almost every client who calls him wants "a brand," whether it makes sense or not. Awareness of branding has grown so much, he says, that the knee-jerk response is to hurry up and get one.

"Branding is so pervasive now that it's really difficult to make your client's brand stand out," the principal of Sabingrafik notes.

Sabin's approach to success is to come up with an identity that surprises the viewer. One way to do this is to combine elements that are slightly incongruous. Think of Apple Computer, he says. What does a piece of fruit have to do with computers? "But it is a compelling image, and that element of surprise works," Sabin says.

The designer used this approach to recreate the identity for Sensa, a decade-old, herbally enhanced drink that is lacking only in investors to bring it to market in its new guise. The product's developer, Karim Amiryani, owner of Tamansari Beverage, whose strength is in blending delicious and attractive natural fruit drinks, has struggled to find the right market for his product. His initial approach had been to market the drink to health-minded women, but he now feels there is a much larger market among young adults of both sexes. He asked Sabin to create a package for this new demographic.

That the bottle would be clear was a given, since Amiryani had gone to great lengths to develop a delicious, brightly colored drink using only natural ingredients and wanted to show off the product. The seemingly incongruous rhinoceros graphic for the bottle derived from surfers' use of the word rhino to describe a large wave, and Sabin's design shows a wave curling back over the animal.

To that nod to youth culture Sabin added to the glass of the bottle two molded rings that simulate barbed wire, which is a popular tattoo image. The letterforms used for the name *Sensa* are influenced by graffiti and have the same spiky tone as the wire, the wave, and the rhino's horns.

"The elements themselves don't seem to match," says Sabin, "but hopefully it all comes together when the bottle sits on the shelf, vying for attention amongst all of the competitors' bottles."

New

LOGO SEARCH

Keywords Arts

Type: ◯ Symbol ◯ Typographic ◯ Combo ⦿ All

A

B

C

D

1

2

3

4

5

1

2

3

4

5

1

2

young@art

3

4

5

1A Ⓓ Howalt Design Studio, Inc. Ⓒ Hard Drive 1B Ⓓ Felixsockwell.com Ⓒ EW 1C Ⓓ Art Chantry Ⓒ Stereolab 1D Ⓓ Felixsockwell.com Ⓒ Creo 2A Ⓓ Felixsockwell.com Ⓒ Creo

2B Ⓓ Chermayeff & Geismar, Inc. Ⓒ Graphic Arts USA 2C Ⓓ Howalt Design Studio, Inc. Ⓒ Howalt Design Studio, Inc. 2D Ⓓ Prejean LoBue Ⓒ Prejean LoBue 3A Ⓓ Rickabaugh Graphics Ⓒ Invisible Ink

3B Ⓓ Trickett & Webb Ⓒ London Institute 3C Ⓓ Sabingrafik, Inc. Ⓒ Design Safari 3D Ⓓ Tharp Did It Ⓒ The Design Conference that Just Happens to Be in Park City 4A Ⓓ Felixsockwell.com Ⓒ Creo

4B Ⓓ Gardner Design Ⓒ Amber Lear 4C Ⓓ Jeff Fisher LogoMotives Ⓒ Jeff Maul 4D Ⓓ Felixsockwell.com Ⓒ Creo 5A Ⓓ Howalt Design Studio, Inc. Ⓒ Herman Miller 5B Ⓓ After Hours Creative Ⓒ The Chair Academy

5C Ⓓ Design One Ⓒ Drexel Heritage 5D Ⓓ Sayles Graphic Design, Inc. Ⓒ Christine's 20th Century Design

1

🅓 = Design Firm
🅒 = Client

LOGO SEARCH

Keywords | **Miscellaneous** |

 Type: ○ Symbol ○ Typographic ○ Combo ● All

N E X T
M E D I A

2

3

4

5

1C 🅓 Made on Earth 🅒 Next Media 1D 🅓 Howalt Design Studio, Inc. 🅒 AT&T 2A 🅓 Saturn Flyer 🅒 KRYPTOSIMA 2B 🅓 Art Chantry 🅒 The 3B 2C 🅓 Prejean LoBue 🅒 Motorola 2D 🅓 Prejean LoBue 🅒 A Helping Hand

3A 🅓 Modern Dog Communications 🅒 Jackson Remodeling 3B 🅓 Art Chantry 🅒 Black Dog Forge 3C 🅓 Felixsockwell.com 🅒 Blackfoot Indian Construction 3D 🅓 Gardner Design 🅒 Brain Cramps

4A 🅓 Art Chantry 🅒 The Makers 4B 🅓 Hornall Anderson 🅒 Personify 4C 🅓 Pure Imagination Studios 🅒 Pure Imagination Studios 4D 🅓 Hornall Anderson 🅒 CW Gourmet/Mondeo 5A 🅓 Made on Earth 🅒 Made on Earth

5B 🅓 Modern Dog Communications 🅒 All The Rave, Inc. 5C 🅓 Kontrapunkt 🅒 Danish Medicines Agency 5D 🅓 Kontrapunkt 🅒 The Danish State Information Service & Royal Danish Ministry of Foreign Affairs

170

Ⓐ Ⓑ Ⓒ Ⓓ

 ❶

SCRIPMASTER

BIG BOWL
AN ASIAN CAFE

 ❷

RETROLINER

PARTNERS IN CARING
DONCASTER

SSPC Children's Center

 ❸

KPLOTRA

FRAMESTARS
The Northwest Framing Experts

 ❹

HealthLink

FADICA

 ❺

1A Ⓓ Howalt Design Studio, Inc. Ⓒ Howalt Design Studio, Inc. 1B Ⓓ Sibley Peteet Design Ⓒ Rx.com 1C Ⓓ Gardner Design Ⓒ Scripmaster 1D Ⓓ Essex Two Inc. Ⓒ Lettuce Entertainment

2A Ⓓ Howalt Design Studio, Inc. Ⓒ Retroliner.com 2B Ⓓ Design One Ⓒ Doncaster 2C Ⓓ Graves Fowler Associates Ⓒ Silver Spring Children's Center 2D Ⓓ Art Chantry Ⓒ Legs Against Arms 3A Ⓓ Art Chantry Ⓒ KPLOTRA

3B Ⓓ Design Machine Ⓒ 555 Gallery 3C Ⓓ John Silver Ⓒ FrameStars 3D Ⓓ Cato Purnell Partners Ⓒ Grand Hyatt Jakarta 4A Ⓓ Liska + Associates Communication Design Ⓒ HealthLink

4B Ⓓ Wages Design Ⓒ Quantum 4C Ⓓ Gardner Design Ⓒ Intracare 4D Ⓓ Graves Fowler Associates Ⓒ Foundations and Donors Interested in Catholic Activities, Inc. 5A Ⓓ James Lienhart Design Ⓒ Junior Womens Association

5B Ⓓ Richards Brock Miller Mitchell & Associates Ⓒ Firehouse Ministries 5C Ⓓ Boelts/Stratford Associates Ⓒ Colorado Dance Festival 5D Ⓓ Jeff Fisher LogoMotives Ⓒ Triangle Productions!

A **B** **C** **D**

D = Design Firm
C = Client

LOGO SEARCH

Keywords Food

Type: ○ Symbol ○ Typographic ○ Combo ● All

A	B	C	D	
				1
				2
				3
				4
				5

West Side Organics
Identity Design

Grapefruit Design, Iasi, Romania

West Side Organics is a Hayward, California-based start-up company that delivers fresh, organic products to consumers in the San Francisco Bay area. Its founders wanted potential customers to perceive the new operation as a convenient, healthy, and hip part of their lives. At the same time, they wanted an identity that would clearly convey what they called "organicity" to all audiences.

Ash Sud, CEO of West Side Organics, contacted Grapefruit Design of Iasi, Romania, because he wanted to work with an agency that understood his unique business model and was able create a brand that would position his company as a leader in the organic marketplace.

"We entered a rapidly growing market that had established competitors and realized the importance of creating instant brand awareness. We wanted to emotionally connect with our customers," Sud says.

Of course, the new company had no brand awareness in their target market (middle- to upper-income people who want to be healthy but don't have time to shop) and, on top of that, low niche awareness.

"In spite of organic foods becoming more and more mainstream these days all over the world, few people know that fresh, organic produce is actually available for regular delivery to their door in major urban areas," notes Grapefruit Design Chief Creative Officer Marius Ursache.

Ursache likes to use simple, widely recognized icons. For this project, the leaf—an element common to fruits and veggies—was chosen for its simplicity and associations with nature, purity, and health.

The designers selected Info, from FontFont, as the typeface. The smooth, round shape of the letterforms creates a modern, friendly look, as do the all-lowercase letters.

"While trying to keep the symbol very simple, I realized that using a single, simplified leaf would fail to create a memorable logo, since it was too generic," says Ursache. "On the other hand, a fruit or a vegetable would have appeared more complicated and restricted the message the logo needed to convey. So a bunch of leaves imposed itself as the simplest and most straightforward solution." A foliage pattern was created to carry the identity over to most of the company's collateral, such as their delivery vehicles. It is an extension of the logo and transmits the same values: freshness, naturalness, and healthfulness.

Grouping leaves in a bunch further stresses the notion of goodness and makes the symbol much more recognizable. Like all the elements in the logo, the leaves have smooth angles, creating a soft, modern look.

The delivery vehicles have served as the most public manifestation of the identity thus far, and have already become a popular icon in the Bay area. The surface of the company's white vans is about one-quarter a painted jungle of leaves, and the owner's own Volkswagen Beetle also received the leafy treatment over nearly half of its body. The vehicles' light background colors enhance the shades of green Ursache specified and keep the contact information visible, making the autos eye-catching curiosities.

As a direct result of their branded vehicles and logo, West Side Organics has reported a significant increase in its customer base and revenue, as well as sustained press coverage in major local newspapers. "When customers see our leaf-covered delivery van drive up, there is no doubt about who is delivering their food," says Sud.

"The best thing about the design," Ursache says, "is its immense versatility, despite its simplicity. The two shades of green and the leaf motif allow for almost boundless creativity while keeping any future designs well in line with the company's corporate identity. The design gives us as much freedom as we want in any [application]—for stationery, product packaging, signage, and so on."

Ⓓ = Design Firm
Ⓒ = Client

LOGO SEARCH

Keywords **Structures**

Type: ○ Symbol ○ Typographic ○ Combo ● All

Ⓐ Ⓑ Ⓒ Ⓓ

 1

 2

 3

 4

 5

	A	**B**	**C**	**D**
1				
2				
3				
4				
5				

1A Ⓓ Sayles Graphic Design, Inc. Ⓒ Homeworks 1B Ⓓ MB Design Ⓒ Kulshan Community Land Trust 1C Ⓓ Howalt Design Studio, Inc. Ⓒ Janene Brown 1D Ⓓ Sabingrafik, Inc. Ⓒ Sea Country Homes

2A Ⓓ Sabingrafik, Inc. Ⓒ McMillin Homes 2B Ⓓ Essex Two Inc. Ⓒ Burack & Company 2C Ⓓ Mitre Design Ⓒ Winston-Salem Downtown Arts District 2D Ⓓ Balance Ⓒ Inn at the Market

3A Ⓓ Mires Ⓒ Portcullis Management 3B Ⓓ Roman Design Ⓒ Fortress Technologies, Inc. 3C Ⓓ Mitre Design Ⓒ St. Paul's Episcopal Church 3D Ⓓ Kiku Obata & Company Ⓒ Simon Property Group

4A Ⓓ Tim Frame Ⓒ Axis Group 4B Ⓓ Art Chantry Ⓒ Pitch & Groove 4C Ⓓ Jon Flaming Design Ⓒ Max Barney 4D Ⓓ Jon Flaming Design Ⓒ Central & Southwest 5A Ⓓ Chase Design Group Ⓒ The Paltrow Group

5B Ⓓ Hornall Anderson Ⓒ Space Needle 5C Ⓓ Howalt Design Studio, Inc. Ⓒ Work, Inc. 5D Ⓓ Dotzero Design Ⓒ Advertising Federation of Wichita

The Wexan Group, Ltd.

① 1

HANOVER ERLICH

REAL ESTATE

SHINING CITY
RECORDS

METROPOLIS

② 2

Urban Market
DEVELOPMENT

URBANGOODS.com

③ 3

ROCKEFELLER
CENTER

WESCO

④ 4

M·C·D·S
INCORPORATED

TRUJILLO

BUILDING AND DEVELOPMENT COMPANY

INSIGNIA

⑤ 5

	A	**B**	**C**	**D**

1

2

3

4

5

LOGO SEARCH

Keywords Transportation

Type: ○ Symbol ○ Typographic ○ Combo ● All

Ⓐ Ⓑ Ⓒ Ⓓ

① ② ③ ④ ⑤

1C Ⓓ AdamsMorioka, Inc. Ⓒ Nickelodeon 1D Ⓓ Device Ⓒ Forbidden Planet 2A Ⓓ Modern Dog Communications Ⓒ K2 Snowboards 2B Ⓓ Kiku Obata & Company Ⓒ Planet Comics
2C Ⓓ CRE8 Communications, Inc. Ⓒ CRE8 Communications, Inc. 2D Ⓓ Hornall Anderson Ⓒ Recharge 3A Ⓓ Monigle Associates Inc. Ⓒ Cessna Aircraft Company 3B Ⓓ Howalt Design Studio, Inc. Ⓒ Work, Inc.
3C Ⓓ Cincodemayo Ⓒ Kamikaze Restaurant 3D Ⓓ Klauddesign Ⓒ SFO 4A Ⓓ Orange 32 Ⓒ Dillon Creative 4B Ⓓ Gardner Design Ⓒ Home Oil Company 4C Ⓓ Jon Flaming Design Ⓒ Objex
4D Ⓓ Hornall Anderson Ⓒ Travel Services of America 5A Ⓓ Klauddesign Ⓒ SFO 5B Ⓓ Buz Design Group Ⓒ Nissan Motor Company 5C Ⓓ Wages Design Ⓒ Arris 5D Ⓓ Dotzero Design Ⓒ Mostella Records

	A	B	C	D
1				
2				
3				
4				
5				

①

②

③

④

⑤

index

LogoLounge is too big for just one book, so we made it a Web site, too. Log onto www.logolounge.com/book1 for electronic access to the logos in this book. Search for logos by keywords, client or design firm name, client industry, or type of mark, and get designer credits and contact information along with the logos.

And while you're at the site, take a few minutes to catch up on identity-industry news and trends, check out our monthly picks of great logos, and look inside the studio of our featured designer. With all that inspiration, you're sure to come up with great logo designs of your own.

directory

2b1a
Germany
49.17.51.96.83.79

AdamsMorioka, Inc.
United States
310.246.5758
www.adamsmorioka.com

Addis
United States
510.704.7500
www.addis.com

After Hours Creative
United States
602.275.5200

Angryporcupine
United States
408.873.9021
www.angryporcupine.com

Art Chantry
United States
314.773.9421

Artimana
Spain
34932075356
www.artinet.net

Artomat Design
United States
206.623.9294
www.artomatdesign.com

**Associated Advertising
Agency, Inc.**
United States
www.associatedadv.com

Balance
United States
830.990.2888
www.studiobalance.com

BBK Studio
United States
616.459.4444
www.bbkstudio.com

Be Design
United States
415.451.3530
www.beplanet.com

Bel Bare
Australia
0413.459.610
www.belbare.com

Beth Singer Design
United States
www.bethsingerdesign.com

Bird Design
United States
616.458.4844
www.birddesign.com

Blue Beetle Design
Singapore
65.323.3282
www.bluebeetledesign.com

Boelts/Stratford Associates
United States
520.792.1026
www.boelts-stratford.com

BrandEquity
United States
617.969.3150.x232
www.brandequity.com

**Braue; Branding &
Corporate Design**
Germany
0471.983.82.0
www.braue.info

Brian Sooy & Co.
United States
440.322.5142
www.briansooyco.com

Bright Strategic Design
United States
310.305.2565
www.brightdesign.com

Bumba Design
United States
818.761.1353

Buz Design Group
United States
310.202.0140
www.buzdesign.com

Cato Purnell Partners
Australia
61.3.9429.6577
www.cato.com.au

Chase Design Group
United States
323.668.1055
www.margochase.com

Chermayeff & Geismar, Inc.
United States
212.532.4499
www.cgnyc.com

Cincodemayo
Mexico
8183425242
www.cincodemayo.com.mx

**Corporate Image
Consultants, Inc.**
United States
813.963.6729
www.cibydesign.com

CRE8 Communications, Inc.
United States
612.227.0908
www.e-cre8.com

Cronan Group
United States
510.923.9755
www.cronan.com

Dan Stiles Design
United States
415.720.3262
www.danstiles.com

Dennis Purcell Design
United States
310.301.0106
www.dennispurcelldesign.com

Design and Image
United States
303.292.3455
www.d-and-i.com

Design Machine
United States
212.982.4289
www.designmachine.net

Design One
United States
828.254.7898
www.d1inc.com

Device
United Kingdom
44.20.7221.9580

DK Design
United States
818.763.9448

Dogstar
United States
205.591.2275

Dotzero Design
United States
503.892.9262
www.dotzerodesign.com

Eisenberg and Associates
United States
214.528.5990
www.eisenberg-inc.com

Elixir Design
United States
415.834.0300
www.elixirdesign.com

Enterprise IG
United States
415.391.9070
www.enterpriseig.com

Essex Two Inc.
United States
773.489.1400
www.sx2.com

Evenson Design Group
United States
310.204.1995

Felixsockwell.com
United States
212.579.5617
www.felixsockwell.com

Flynn Design
United States
601.969.6448

Gardner Design
United States
316.691.8808
www.gardnerdesign.com

Grapefruit Design
Romania
240.32.233068
www.grapefruitdesign.com

Graves Fowler Associates
United States
301.816.0097
www.gravesfowler.com

GTA - Gregory Thomas Associates
United States
310.315.2192
www.gtabrands.com

Hecht Design
United States
781.643.1988
www.hechtdesign.com

Henderson Tyner Art Company
United States
336.748.1364
www.hendersonbromstead.com

Hess Design Works
United States
914.232.5870
www.hessdesignworks.com

Hornall Anderson
United States
206.467.5800
www.hadw.com

Howalt Design Studio, Inc.
United States
480.558.0390
www.howaltdesign.com

Hoyne Design
Australia
61.3.9537.1822
www.hoyne.com.au

Hutchinson Associates, Inc.
United States
312.455.9191

Indicia Design, Inc.
United States
913.269.5801
www.indiciadesign.com

James Lienhart Design
United States
312.738.2200
www.lienhartdesign.com

Jeff Fisher LogoMotives
United States
503.283.8673
www.jfisherlogomotives.com

John Evans Design
United States
214.954.1044

John Silver
United States
425.379.8284
www.johnsilveronline.com

Jon Flaming Design
United States
214.987.6500

Kellum McClain Inc.
United States
212.979.2661
www.kellummcclain.com

Ken Shafer Design
United States
206.223.7337
www.kenshaferdesign.com

Kiku Obata & Company
United States
314.361.3110
www.kikuobata.com

Klauddesign
United States
415.781.6021
www.klaud.com

Kontrapunkt
Denmark
45.33.93.18.83
www.kontrapunkt.dk

Laura Manthey Design
United States

Lexicon Graphix, Inc.
United States
315.423.0510
www.lexicongraphix.com

Lieber Cooper Associates
United States
312.527.0800
www.liebercooper.com

Liska + Associates Communication Design
United States
312.644.4400
www.liska.com

Logoboom
United States
323.650.6513
www.logoboom.com

Luce Beaulieu
Canada
514.849.9075

Made on Earth
United States
818.761.4545
www.madeonearthstore.com

Marcus Lee Design
Australia
61.03.9429.3100
www.marcusleedesign.com.au

MB Design
United States
360.733.1692
www.mb-design.com

McMillian Design
United States
212.665.0043
www.mcmilliandesign.com

MetaDesign
United States
www.metadesign.com

Miaso Design
United States
773.862.5822
www.miasodesign.com

Minale Tattersfield & Partners Ltd.
United Kingdom
44.0.20.8948.7999
www.mintat.co.uk

Mires
United States
619.234.6631
www.miresbrands.com

Miriello Grafico, Inc.
United States
619.234.1124
www.miriellografico.com

Mitre Design
United States
336.722.3635
www.mitredesign.com

Modern Dog Communications
United States
206.789.7667
www.moderndog.com

Mojo Unlimited, LLC
United States
www.mojounlimited.com

Monigle Associates Inc.
United States
303.388.9358
www.monigle.com

Orange 32
United States
631.864.0082
www.orange32.com

Pat Taylor Inc.
United States
202.338.0962

Phinney/Bischoff Design House
United States
206.322.3484
www.pbdh.com

Planet Propaganda
United States
608.256.0000
www.planetpropaganda.com

Plumbline Studios
United States
www.plumbline.com

Pogon
Yugoslavia
381.11.626.039

Portal 7 Design
United States
212.254.4236

Prejean LoBue
United States
337.593.9051
www.prejeanlobue.com

Proart Graphics/Gabriel Kalach
United States
305.532.2336

Pure Imagination Studios
United States
630.933.8167
www.pureimagination.com

Randy Mosher Design
United States
773.973.0240
www.randymosherdesign.com

Renegade Design
United States
330.899.0649

Richard Leland
United States
443.604.3420
www.leland.nu

Richards Brock Miller Mitchell & Associates
United States
214.987.6500
www.rbmm.com

Rickabaugh Graphics
United States
614.337.2229

Rodgers Townsend
United States
314.436.9960
www.rodgerstownsend.com

Roman Design
United States
303.526.5740

S Design, Inc.
United States
www.sdesigninc.com

Sabingrafik, Inc.
United States
760.431.0439

Sackett Design
United States
415.929.4800
www.sackettdesign.com

Sandstrom Design
United States
503.248.9466
www.sandstromdesign.com

Sanna Design Group, Inc.
United States
516.719.6235
www.4sdg.com

Saturn Flyer
United States
571.212.0338
www.saturnflyer.com

Sayles Graphic Design, Inc.
United States
515.279.2922
www.saylesdesign.com

Sibley Peteet Design
United States
512.473.2333
www.spdaustin.com

Simon & Goetz Design
Germany
49.69.96.88.55.0
www.simongoetz.de

SPATCHURST
Australia
61.2.9360.6755
www.spatchurst.com.au

Spiral Design Studio
United States
518.432.7976
www.spiraldesign.com

Spot Color Inc.
United States
703.378.9655
www.spotcolor.com

Start Design Ltd.
England
020.7269.0101
www.startdesign.com

Sterling Group
United States
www.sterlingbrands.com

Stone & Ward
United States
501.375.3003
www.stoneward.com

Studio Rayolux
United States
206.286.9963
www.rayolux.com

t.b.g. design
United States
770.474.6600
www.tbgdesign.com

Tharp Did It
United States
408.354.6726
www.tharpdidit.com

Tim Frame
United States
614.598.0113

Treehouse Design
United States
310.204.2409

Trickett & Webb
United Kingdom
44.0.20.7388.5832

Triple 888 Studios
Australia
61.2.9891.2888
www.triple888.com.au

Vanderbyl Design
United States
415.543.8447
www.vanderbyldesign.com

Visible Ink Design
Australia
61.3.9510.7455
www.visibleink.com.au

Wages Design
United States
404.876.0874
www.wagesdesign.com

Webster Design Associates Inc.
United States
402.551.0503
www.websterdesign.com

Willoughby Design Group
United States
816.561.4189
www.willoughbydesign.com

Woodhead International
Australia
61.8.8223.5013
www.woodhead.com.au

Zenarts Design Studio
United States
703.757.9551
www.tangled-web.com

about the authors

Bill Gardner is president of Gardner Design in Wichita, Kansas and has produced work for Bombardier/Learjet, Thermos, Nissan, Pepsi, Pizza Hut, Coleman Outdoor, Excel, Cargill Corporation, and the 2004 Athens Olympics. His work has been featured in *Communication Arts, Print, Graphis, New York Art Directors, Step By Step,* Mead Top 60, the Museum of Modern Art, and many other national and international design exhibitions. His works and writings regarding corporate identity and three-dimensional design have been published in numerous books and periodicals. Gardner has judged a number of design competitions nationally and internationally, including the *Communication Arts Design Annual.*

Catharine Fishel runs Catharine & Sons, an editorial company that specializes in working with and writing about designers and related industries. She frequently writes for *Step Inside Design, PRINT, U&lc Online, ID,* and other trade publications, and provides editorial support for LogoLounge.com. She is the author of *Paper Graphics, Minimal Graphics, Redesigning Identity, The Perfect Package, Designing for Children,* and the forthcoming books *The Power of Paper in Graphic Design* and *The Inside Business of Graphic Design.*